MILTON HEBALD

MILTON

A Studio Book

HEBALD

Frank Getlein

THE VIKING PRESS · NEW YORK

Book Designed by: Christopher Holme

1

Every artist sooner or later, and some of them all the time, creates a work in his own image, not necessarily a formal self-portrait but one that takes its life and being from the artist's intimate awareness of his own nature.

In many early Renaissance paintings the hordes of spectators gather around some sacred event and gaze, transfixed, at what is happening. Except one. One man stares coolly out at the viewer, ignoring the epoch-making event and the larger-than-life personages. He is, of course, almost always looking not at the viewer but at himself in the mirror: he is the artist.

There is that great ceiling at Würtzburg, full of floating gods and goddesses and minor German nobility and, tucked away in one corner, the earnest face of Giambattista Tiepolo, closely attentive to every detail of the vast ceiling as if he knew that to take his hand away for a moment, or even to glance elsewhere, would dissolve the whole airy and elegant world into the frail gossamer it really is.

More sober and stately, Velázquez nevertheless takes essentially the same self-view in his group portrait of the Infanta, her royal parents, her maids of honor, her dog, and her dwarf—and her painter. All these excellencies and highnesses would cease to exist without the steady, patient labors of the sturdy painter faithfully putting brush to canvas.

Milton Hebald has made such a work. Less overtly a self-portrait than any of the paintings just mentioned, his bronze sculpture "Tempest" effectively sums up the artist's relationship to his art. The standing couple are Prospero, the exiled magician, and his daughter, Miranda, poised on their island as the father raises his arm to conjure up the tempest that will shipwreck Ferdinand and the rest of the party from Naples.

Hebald does not go about conjuring up tempests, and he is no admirer of shipwrecks. All the same, there is much of Prospero in him. Prospero was in exile—apparently in Bermuda, which is a bearable exile. Hebald, because of the nature of his artistic talent and the uses to which he puts that talent, is likewise in exile—from his native America. He lives in Rome, which he finds fascinating and endlessly consoling, as well as irritating, frustrating, and amusing. Like Prospero, Hebald the sculptor can raise his hand and produce magical effects, can bring into existence persons who were not there before, such as this Prospero and Miranda. Hebald's magic, moreover, like Prospero's, is Baroque in style and Baroque at one remove.

Prospero's original creator, Shakespeare, was Baroque at one remove by reason of geography. Because he lives in and loves the city of all cities that takes its form from the Baroque spirit, Hebald's one remove is that of time. Neither he nor anyone else in the twentieth century can take with total seriousness the elaborate sonorities of the sixteenth and seventeenth centuries. Baroque came into existence serving certain very clear aims of religion, politics, and even economics. Those aims have long since ceased to be relevant to society. Yet the language created by Baroque in the service of those aims continues to survive as an eloquent and utterly convincing language, one beautiful to hear, sublime to speak.

But the serious artist cannot go around speaking a beautiful language without meaning. This is the road to the triolet or to the soprano's cadenza. For Hebald, enchanted with the beauty and power of the Baroque, increasingly a master of that beauty and power, it is not enough that the manner is a lovely thing to look at, a gratifying thing to create. He has consistently endowed it with meaning, a meaning quite foreign to that of Bernini and the great Baroque masters, one even somewhat antithetical to the social scheme they stood for. Hebald does this in a variety of ways. He does it with particular grace and insight in the "Tempest."

As the magician raises his hand to create the tempest, the great winds have already begun to blow—a typical Baroque compression of time: the gesture that begins the action is already surrounded by the action. Miranda's hair, Prospero's long beard, and the flowing draperies of both figures are caught up in the freshening wind. Their bodies are stiffened in legs and trunk exactly as people stiffen against a rising wind. The Baroque elements are magnificently carried out, especially the draperies. They could have come from the Roman Baroque master especially beloved by Hebald, Ber-

THE TEMPEST III. 7' high; 1966.

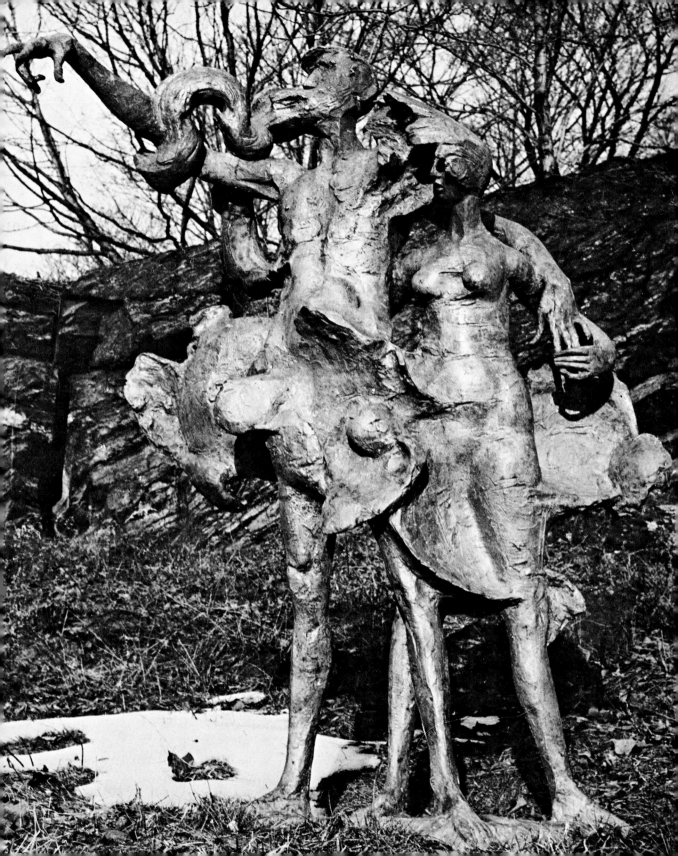

ELEMENTS IN A LIFE STUDY. 24″ high; plaster; 1940.

ELEMENTS IN A LIFE (dedicated to Stephen Crane). 30″ x 50″; plaster; 1940.

nini. The flowing clothes form a cloud band around the waists of the pair, an active, turbulent, roiling cloud of the kind associated with tempests.

Hebald normally makes several versions of a single sculpture—at least two or three, sometimes five or six—each in a different size, from the first small sketch in wax through a life-size or even larger bronze. He has never simply enlarged from stage to stage. Each new size is also a genuinely new sculptural embodiment of the theme. In one version of the "Tempest," five feet four inches high and in the collection of Mr. and Mrs. Norman Bernstein of Washington, the cloud reveals, in front of Prospero, the buttocks of a cherub who seems to be swirling around the magician, an effect heightened by an outcropping of cloud-cloth at his right hip, which suggests a head. Accepting that interpretation, the viewer is reminded of the tempestuous figure of God the Creator in the first panel of Michelangelo's Sistine ceiling. This impression is underlined by the hand and fingers of the magician, which recall the creative hand of God in the middle panel of that ceiling, the great, power-latent hand that calls Adam to life. The ceiling, we remember, is often cited as the beginning of Mannerism and the Baroque in Roman art.

In another version of the "Tempest," thirty-two inches high and in the C. V. Starr Collection, Brewster, New York, the waistcloths are not so much clouds as shells from underseas. In that version, too, melting runs of wax survive in the bronze down Prospero's great chest, as if they were running water. At the feet of Prospero and Miranda is a plant of some unidentified kind that looks like a certain form of coral. Through such means the ethereal, even meteorological air of the Bernstein "Tempest" has become, in the Starr "Tempest," subaqueous. We are reminded by the artist that the original play is of the sea as well as of the air and that one of the loveliest dirges in literature begins, "Full fathom five thy father lies."

Now, clearly, a sculptor who can manage all these references without being especially overt about any of them is an accomplished artist. Hebald is. But neither the combination of artistic and literary history noted in the several versions of the "Tempest" nor the rediscovery of Baroque facility is enough to satisfy Hebald. It has been said that the drapery and the hair could have come off a Bernini fountain or bronze altarpiece. So they might have. But neither the figures nor the spirit of the piece could have had anything to do with that master of the Baroque. Both figures are skinny to a degree. Prospero's trunk is as straight as the trunk of a tree. Miranda's

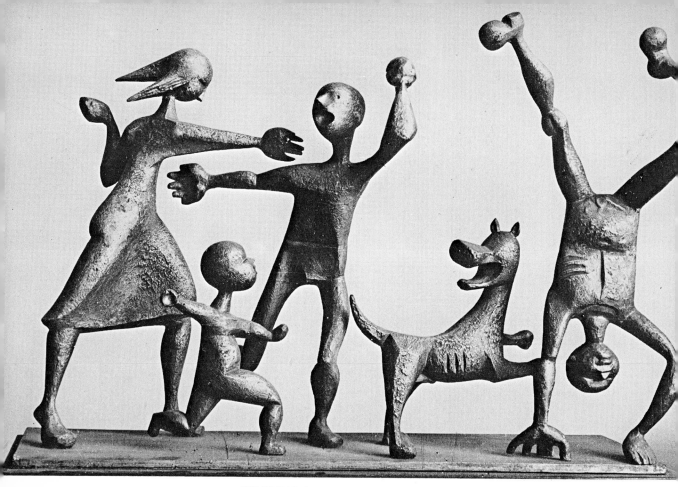

CHILDREN'S GAMES. 20″ high x 28¼″ x 8″; aluminum; 1949.

body is a little softer, more swelling here and there, but she is still a slightly gawky, older adolescent, her breasts stuck on her chest like apples on a plate. Within the coral-cave of the hair around her face, her mouth opens in little-girl amazement.

These elements contrast strongly with the Baroque ones. We are seeing human ungainliness and awkwardness. We are seeing human reality, in short, as contrasted with the inflated dream of the Baroque ideal. Thus it is, in this piece, that Hebald reconciles his passion for Baroque with his profound awareness of humanity and of his own century. Like Blondin on the wire over Niagara Falls, Hebald practices the Baroque, extols the Baroque, and thoroughly enjoys the Baroque, while at the same time gently mocking its pretensions and contrasting its grandeurs with human frailities. It is a complex, highly sophisticated position, but then its author is a complex, highly sophisticated artist.

2

More than most other people, artists are likely to know at a very early age that they are artists and to start very young to learn what they must do to follow their vocation. Milton Hebald cannot remember a time when he did not already know that he was an artist. He seems also to have recognized early that his gift was for sculpture. He was precocious not only in talent and in work done but in recognizing, seeking out, and placing himself in situations that would further his artistic growth. He received his earliest reproduction and art criticism, for example, at the age of eight in the *Juvenile Magazine,* published "for its young friends" by McCreery's department store in New York. Young friend Hebald was acclaimed for his "really splendid picture of the New York skyline, with the East River and the bridge and the ferry."

Milton Elting Hebald was born in New York on May 24, 1917, at his home at 166 The Bowery, where he lived for the first four years of his life. His father, Nathan, a jeweler, was born in Cracow, Poland; his mother, Eva Elting, was born in Greenwich Village. When Milton was six, his father was shot outside his store by members of the Little Augie gang in the course of a holdup.

During most of his childhood, Hebald lived at 97th Street and Madison Avenue. He became something of a neighborhood celebrity because he used the wide sidewalks in that part of New York for large-scale drawings in colored chalk. To this day, when asked how he got interested in art, Hebald is apt to reply, "I learned it in the streets."

He remembers as one of the high points of his preschool life a sidewalk drawing of one of the old double-decker Fifth Avenue buses, "drawn from

life," just outside the playground at 97th Street. Perhaps significantly, the ground for the drawing was at the Sculptors' Gate of Central Park, with the self-portrait of Thorvaldsen, the Dane who worked in Rome.

At about the age of eight—more or less simultaneously with his triumph in McCreery's magazine—someone gave the boy a box of modeling clay in colored strips. On taking the strips into his hands, pressing them, shaping them, and seeing that they took and held the shapes he gave them, the boy recognized that he was not only an artist but a sculptor. He was home.

Like most serious children in our time, Hebald had difficulty with people and institutions who saw him solely as a child to be put through the standard paces, while he himself increasingly regarded those paces as a waste of precious time that should be spent in learning and practicing his art.

Still, he managed to get himself an amount of art training and exposure far above that of the usual schoolchild. Hebald went often to the nearby Metropolitan Museum of Art with his three older sisters. "I considered it my own personal museum," he has said. He was strongly attracted to the sculpture on view, from all periods and all countries. But his two favorite pieces were "Death and the Sculptor," by Daniel Chester French, and "Two Natures Struggling within Me," by George Grey Barnard.

Through connections and just plain determination, the boy Hebald managed to get himself admitted to the studios of both these sculptors. French graciously showed him around his Gramercy Park place, answering questions and demonstrating techniques. Barnard was also working when his young visitor arrived. The works in progress included the big arch of peace —"very like William Blake," Hebald recalls—and the Lincoln statue that went to Liverpool. The boy enormously appreciated the kindness of the two men he by now regarded as older colleagues.

In grammar school he won every art award in sight, including the Saint-Gaudens Medal from the School Art League. Soon after that he won a scholarship to the School Art League and enrolled in the sculpture class conducted by Adele Spitzer and the life drawing class under Anne Goldwaithe at the Art Students League. The Saturday program for children was new and an experiment for the League. Hebald may have had a decisive influence on its fate. When he arrived in the life class, the outraged model got off the stand to protest, "I can't pose for a boy like that. Why, I've got a son at home older than he is." Milton was ten, the youngest student in the League's history up to that point.

TIGHT ROPE. 9¼″ high; 1947.

PLANTER. 10½″ high; 1948.

In high school he won several junior prizes in the national competitions in soap sculpture sponsored by the Procter & Gamble company. One winner was a little squad of soldiers, which has turned, appropriately, to a glowing ivory color, and is still owned by an aunt. Another winner was a model of a nun in flowing robes.

Hebald studied at the National Academy of Design for a year, but since the Academy did not admit students to sculpture classes until after four years, he transferred to the Beaux-Arts Institute. He was now in the somewhat crowded situation of attending high school during the day and the Institute at night. Between the two sets of classes he spent most of his time at the New York Public Library on 42nd Street, patiently copying Old Master drawings from reproductions. Hebald believes passionately in the value of close study of the Masters, especially in drawing. He is appalled at current practice that seeks chiefly to liberate the student's imagination and originality at the expense of technical mastery.

"Copying Old Master drawings," he said recently, "is far more profound than drawing from life. Both are important, but Old Master copying should precede drawing from the nude. Many paintings I see in museums now are familiar: it's like meeting old friends, because I know, I have done, the drawings behind them. People today don't have the perseverence. They want to learn quickly, and this is reflected in modern teaching techniques. But you have to copy, the way children copy adults."

The sessions with the Old Masters on the way to the Beaux-Arts sculpture class were one substantial addition to the day of a high-school boy. Another activity was added when he got permission, through the mother of a classmate, to observe human dissections at the Flower Hospital in return for making anatomical drawings for the staff. Again, the boy was seeking out and obtaining classical disciplines all but unavailable to American student artists of the time and unthinkable for one of his age.

Meanwhile, back at Haaren High School, classwork held less and less interest. The only thing really capable of catching and holding his interest was the group painting of a mural for the school and the subsequent arrival of the Mexican muralist, David Siqueiros, to inspect the work. Hebald's loaded schedule of sculpture training left him no time at all for homework for regular courses. His grades suffered. In 1935, in the middle of his senior year, he dropped out.

TREE OF LIFE. 25″ high; 1948.

He did not think of it as dropping out. For him—and in fact—it was the beginning of his career. He obtained a studio on Waverly Place, given in exchange for showing lofts to potential tenants and "keeping bums out of the building." He was seventeen.

The New Deal years were a great time to be an artist in New York, and after setting himself up, Hebald got a job on the W.P.A. teaching project, working in settlement houses around town. He worked for an extended spell at the New York Boys' Club branch at First Avenue and 111th Street, where he was first exposed to Italians in any large number. In retrospect, from Rome, it strikes Hebald now that he knew at once that he liked Italians, that they understood a great deal about art by sheer heredity, and that, as an artist, he was immediately at ease with them.

He exhibited at the John Reed Club and got a favorable mention in *The New York Times.* He entered and won the annual competition held by the American Artists' Congress, the prize being a one-man exhibition at the A.C.A Gallery. This, his first one-man show, opened on November 14, 1937, to uniformly enthusiastic response from the critics.

The *Times* called Hebald "an uncompromising young modernist . . . influenced by Zadkine and Lipchitz and perhaps Lehmbruck . . . much personal drive and dynamism . . . a promising feeling for essential rhythm."

The *Post*'s critic said, "Everything he touches, whether it be plaster, stone, wood or bronze is impressed with an extraordinary sculptural sense. The innovations of Lipchitz he carries into the realm of dance and swing music with amazing rhythmic fertility. He takes up sweatshop subjects, workers in the yoke of machines, effectively using realistic devices with rare audacity."

Jacob Kainen called the show "the most impressive sculptural debut in several years . . . a crackling good exhibition of pieces which reveal a vigorous and original grasp of sculptural form and an animating social purpose. There is genuine spirit in the way Hebald conceives a swing band or a dancer and the conception is carried out in fresh, moving sculptural terms. And there is tragedy in the attitude and design of 'Operator' and 'Shoemaker.' There is humor in 'Pickets' and some of the terra-cotta pieces and monumentality in the studies of workers."

All in all, it was quite a reception for a youth just turned twenty-one.

On turning twenty-one, too, Hebald married a Hunter College girl he had met at a dance for the benefit of the Spanish Loyalists. Cecille Rosner was

CIRCUS MAXIMUS. 40″ high; cement (later edition in bronze); 1950.

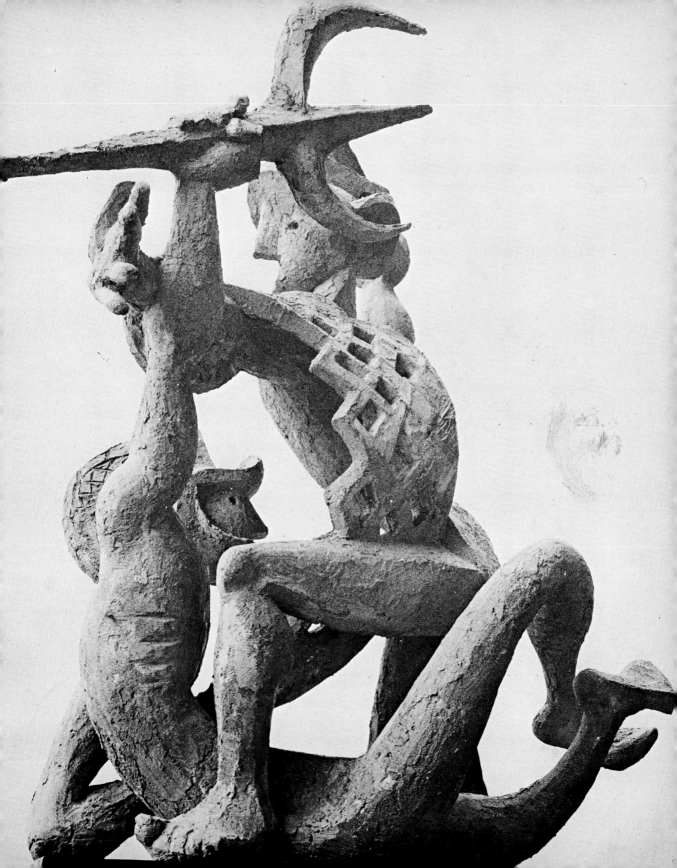

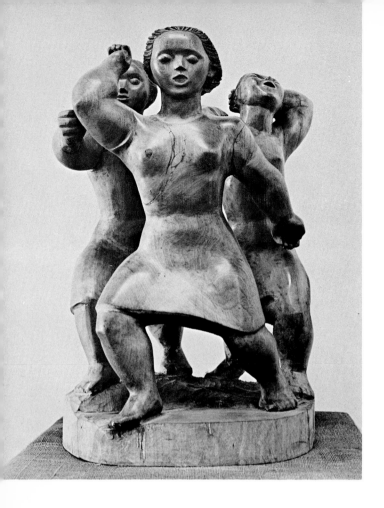

THREE GIRLS. 13″ high; mahogany; 1940.

THE WIND. 65″ high; tulipwood; 1955.

a premedical student, to whom Hebald had lied about his age in order to impress her. The truth came out at the marriage-license counter.

Married and with a rousing reception from the critics, the young sculptor rapidly became a full-fledged member of the New York art world. He was invited to join the Sculptors' Guild, and he did. In that first show at A.C.A., he sold his first piece of sculpture, a landmark in any artist's career. The work was a marble torso of a boy. The purchaser was Victor Wolfson, the playwright. Other exhibitions followed. He began showing regularly at the Whitney Museum of American Art, which was still down on 8th Street and was a more homey place than it has been on 54th Street or Madison Avenue. He graduated from the W.P.A. teaching program into its creative project. He

18

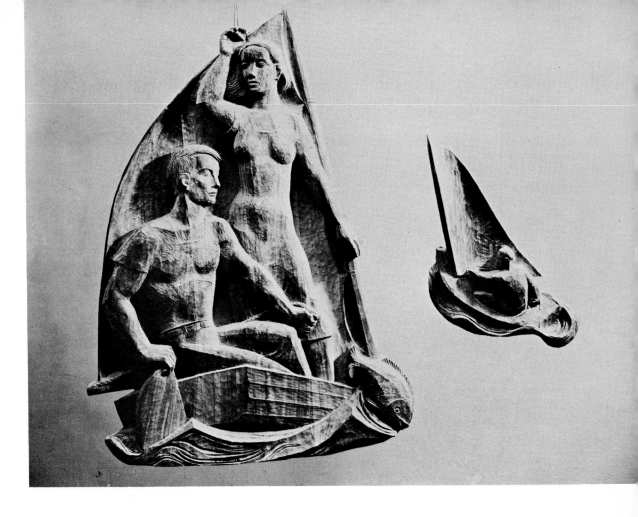

BOATING ON TOMS RIVER. 60″ high; walnut; 1940.

won and executed a government commission for a five-foot wood carving for the post office at Toms River, New Jersey: a boy and a girl in a catboat. He showed in Philadelphia and in Chicago.

As all artists who lived through the period remember, however, acceptance, exhibition, and general adulation were no guarantee, in the 1930s, of an adequate income. Much as he had forced his boyhood into channels useful for his profession, Hebald, confronted with the necessity of earning money to supplement what he was making in sculpture, made sure that all of his outside jobs were related, however tenuously, to that profession. From each of them he added something to the store of technical knowledge and habit that provides one of the fundamental strengths in his art. Hebald in

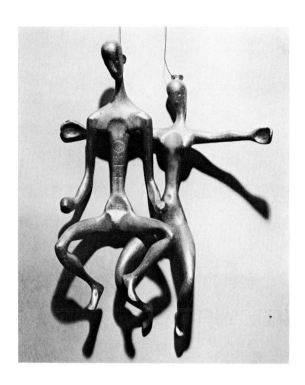

GONGS. 11″ high; 1950.

his fifties in Rome is able to do many things in sculpture because of the avid curiosity of the fifteen-year-old Hebald in New York and of the job selectivity of the twenty- to twenty-six-year-old Hebald.

For nearly a year, for instance, he worked in a department-store display firm making plaster models of floral arrangements and other decorative pieces. With the coming of World War II, Hebald, like numerous artists of his age, went into defense work, but again he was able to find jobs relevant to his real work. For a year or so he worked in bronze foundries, as a molder for parts for submarines and airplanes.

Once he had mastered the technical aspects of this trade, the work itself began to pall. He moved on to Republic Aviation, out on Long Island, where he was assigned to make models for airplane parts. He was able to develop a process of his own which pleased him immensely and which he still uses on occasion. "I made plaster models," he has said, "of a very complex nature, cutting them up in sections, casting them separately, and brazing the parts together. You cannot get the same effect in wax casting. It was my own technique, done with a plaster model and molded in green sand."

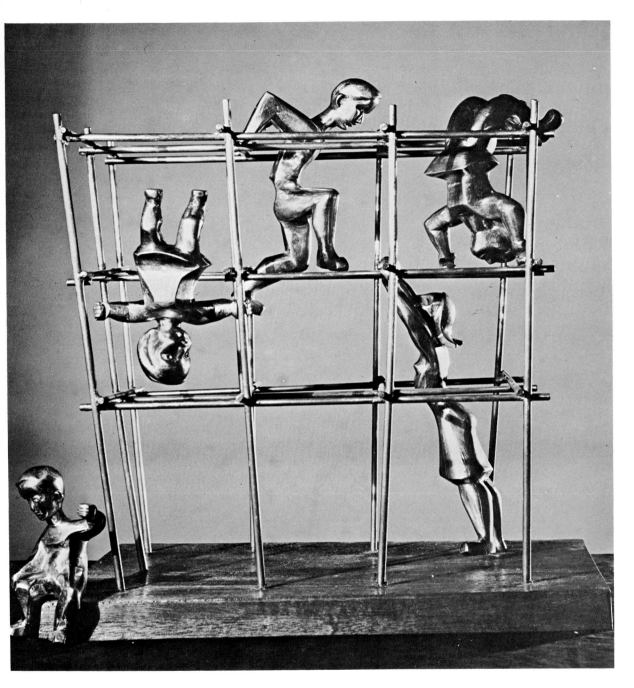

JUNGLE GYM. 14" high; 1946.

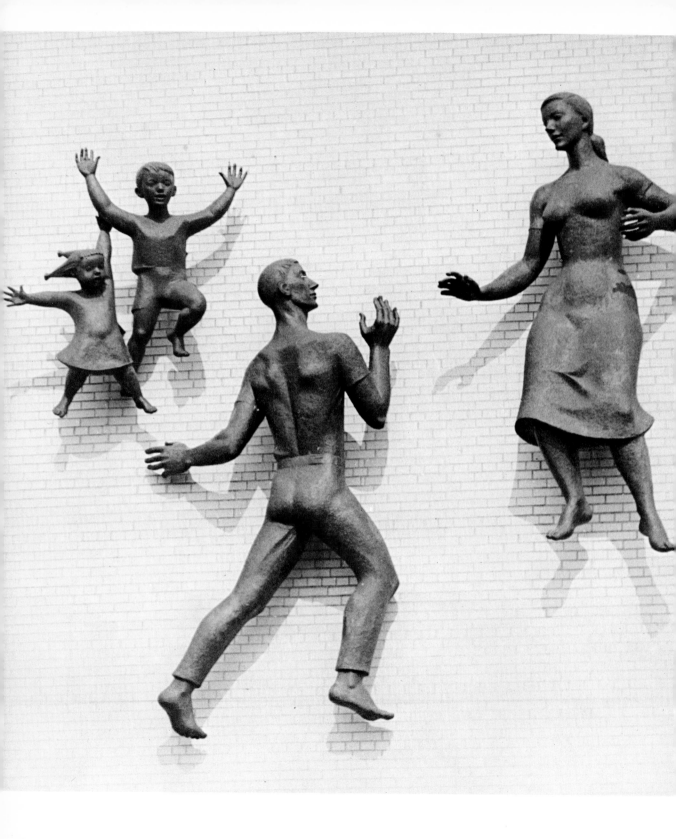

The process has been enormously beneficial to Hebald's sculptural style of open spaces and enveloping forms in bronze.

The climax of his career at Republic Aviation came when he was chosen to design and cast the trophy, in silver and bronze, for the First Fighter Air Force Gunnery and Bomber Meet of 1945. He described his experiences in industry in a perceptive and down-to-earth article, "Sculptor in an Airplane Factory," in *Magazine of Art,* October 1944.

Hebald was drafted in April 1945, and served in the army for one year almost to the day, all of his service being at Camp Lee (now Fort Lee) in Petersburg, Virginia.

After basic training, he was sent to quartermaster school there. He met an old friend and colleague from Cooper Union, where he had taught briefly before his military service. The friend helped him get into the Q.M. program, making models of weapons and other equipment as training aids. And that's what Hebald did for a year. Back in New York, Cecille was working as a physical therapist. They now had a child, Margo, born in 1941, and Hebald was able to leave Camp Lee almost every weekend to visit his family. To pay for the travel, he conducted a small business in making colored sketches of soldiers at a small cost per head. While in the army, he also designed and cast in plaster six Baroque columns for a Petersburg church attended by his colonel.

Hebald was discharged from the army in April 1946 and returned at once to his professional life. There was one commercial interlude. In service, he had met a distant cousin who was in the business of selling party favors. He looked Hebald up after his discharge and informed him that there was a tremendous demand for the little plaster bride-and-groom figurines that traditionally top off wedding cakes. These decorations used to be imported from France and Germany, but the factories that made them had been bombed out. On request, Hebald molded such a couple—"It was quite snappy," the sculptor has recalled—and the salesman asked him to produce them. Answering an advertisement of a "sculpture factory" for sale at Coney Island, Hebald got involved with its owner, a producer of "slum," as it is called—kewpie dolls, mermaids, and the like to be given away in carnival games. Hebald had visions of making his fortune in the business and freeing himself entirely to practice sculpture. He plunged his savings, drew a salary of sixty dollars a week from the partnership, and in very short order got taken for everything he had. He was twenty-nine and flat broke.

VAN ETTEN HOSPITAL FAÇADE. 16' high; 1954.

He returned to teaching at the Brooklyn Museum and Cooper Union, becoming "head of the department" of sculpture at Brooklyn, where, indeed, he *was* the department. He won the Schilling Prize in 1947, for which the judges were Walter Pach and Hugo Robus. The piece, "Three Girls," was given by Hebald to the Philadelphia Museum of Art because of that institution's long interest in sculpture. The same year "Woman with Birds," one of his first postwar wood carvings, was purchased by the Whitney. He worked in three studios in the postwar years, two of them on the upper East Side.

In 1949 Hebald spent the summer as visiting professor at the University of Minnesota. The department head, H. Harvard Arnason, wanted him to stay on, but the prospect of winter in Minnesota struck the Hebalds as chilling. Instead, they bought a station wagon and made a ten-thousand-mile journey of exploration and discovery around the United States. On their return to New York, Hebald had his first postwar one-man show, at the Grand Central Moderns, but the gallery relationship there was neither comfortable nor successful. For three summers he taught at the Skowhegan Art School in Maine. During the winters he gave private instruction, but allowed this gradually to wither away.

Hebald resents teaching because it takes time he might spend more profitably on his sculpture, but he also enjoys it, because "it is a form of contact." He has taught periodically throughout his career and still does, even though the economics of professional life have long dictated against it.

"The artist's life," he has said realistically, "is essentially a very lonely life, the creative part. You go off in your own direction and your own corner. Teaching gives you a proving ground for your ideas. It's a relationship that bears fruit on both sides." Among his students in those years were Elaine de Kooning, Harold Altman, Al Blaustein, William King, Raymond Rocklin, Al Katz, Dmitri Hadzi, Harold Tovish, and Stephen Werlich.

In 1952 Hebald won a major commission, a bronze figure group sixteen feet high for what is now the Nathan B. Van Etten Hospital of Albert Einstein University in the Bronx. The money was excellent and the opportunity to work on a large scale was fascinating, but in addition Hebald had the satisfaction of winning in competition with some very good people: Koren Der Harootian, José de Rivera, and Donald De Lue, the well-established academic sculptor, and Hebald had been among the artists asked by the committee to compete for the commission. In 1954 the hospital figures were

24

WOMAN WITH BIRDS. 47¼" high; teakwood; 1947.

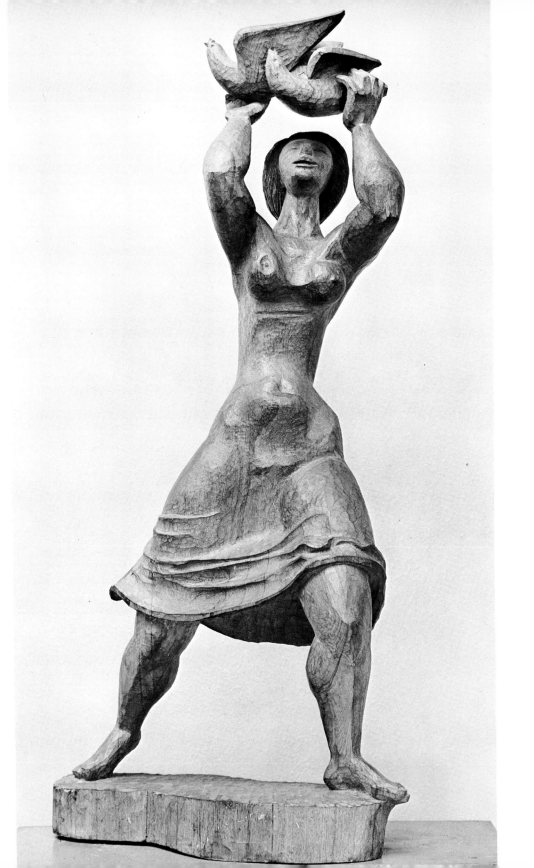

finished and installed. At the same time Hebald won another commission, one that was in some ways less interesting than most of his work then and later and yet one that was perhaps the most important single assignment he has ever undertaken.

The commission was for a sculptural aluminum light complex in a stairway of the Isla Verde Airport, San Juan, Puerto Rico. The work was conditioned to a very large extent by its functional purposes and by the space around it. In the nature of things, it was to be "abstract," or, at any rate, not especially figurative. The architect of the airport, who asked Hebald to take on the job, was Walter Prokosch, who became a major collector of the artist's work and who was to be responsible for a more significant monumental sculptural sequence at another airport, the Pan American terminal at the John F. Kennedy International Airport, New York. But the really important result of the Isla Verde commission was Italy.

Like most American sculptors of the mid-twentieth century, Hebald had long been aware that there were immense advantages connected with bronze casting in Italy and that they were not all a matter of price, although price certainly was one important consideration. When the Isla Verde sculptural form was ready for casting, he decided to have it cast in Milan. Flush with the income from two big commissions so close together, the Hebalds decided, while it was there, to take their first trip to Europe. Hebald's mother had taken his sisters to Europe, on what amounted to finishing tours, because she believed that girls needed the experience of Europe to be completely transformed into adult members of society, but because she felt that boys could look after themselves and the youthful self-apprenticed sculptor was the only boy she had, Milton had stayed at home while his sisters traveled. Now seemed the right time to take a fast look at the Old World while watching over the casting of the Isla Verde piece.

The Hebalds had in mind staying perhaps three weeks. They flew to Copenhagen, hired a car, drove south to Italy, and stayed a total of nine weeks.

Italy was, as it usually is to Americans, an intoxication, a source of immediate and endless delight. Even the irritations of daily life—distinctly different from those in other lands—became, and remain, a source of wry amusement to the Hebalds: Milton "recollects them in tranquility" and re-creates them in an English-Italian patois of his own in which he at once acts out all the parts in an encounter and provides—with what can only be called vocal

gestures—a running explanation of the attitudes involved. The more standard delights were everywhere—the air, the sun, the relaxed pace of the people, the past that is so much a part of the present, the countryside that is so accessible from town.

In addition to visiting Italy, the Hebalds compressed a kind of grand tour of European museums into their nine weeks. They got down to Naples and Pompeii, and they immersed themselves as well in the great museums of France, Germany, Switzerland, Denmark, and the Low Countries. Hebald was voracious about the great collections. He came to realize, finally and forever, that he was, after all, an "artist of the museums."

While in Rome he visited an old friend and former student, at the American Academy. The life there for an artist seemed unbelievable to one fresh from the struggle of living as an artist in New York. Hebald made a note.

Back in America, he spent Christmas in Puerto Rico installing the complicated aluminum light fixture at Isla Verde, as always managing to learn something new, this time the craft of electrical wiring, since the ordinary electrician—or at least the ordinary Puerto Rican electrician—was baffled by the project. Hebald also lost no time in applying for the Prix-de-Rome, granted by the Academy. He won with "The Wind," a superb example of the "pre-de-Rome" Hebald. The Hebalds arrived in Rome in 1955, expecting to stay there a year, perhaps two, and then return to New York and the mixed schedule of teaching and making sculpture. Rome was a kind of holiday.

Fourteen years later, the holiday is still going on, and it has been one of the most productive holidays in recent art history. Hebald has said with a smile, "Michelangelo died at ninety and left perhaps forty or fifty pieces. I am fifty and have made thirty-five hundred." The productivity began at once.

The atmosphere and arrangements at the American Academy in Rome are calculated to bring out whatever is in an artist. If he is a lazy ne'er-do-well at heart, he may practice that for his entire stay and no one will upbraid him. On the other hand, if, like Hebald, he is a driving, producing artist who has been diverted from art too much into the paths of teaching and making a living, then the experience of the Academy can unleash a flood of creation. It did for Hebald.

The Hebalds managed to travel about Europe a good deal while at the Academy, yet sculpture leapt from the hands of the sculptor as if he were

GIRL OF TRASTEVERE. 17" high; 1956.

Opposite: RAPE OF THE SABINES. 27″ high; 1956.

Right: THE PROMISE. 32″ high; 1957.

Opposite: RATTO DI SABINE. 14½″ high; 1956.

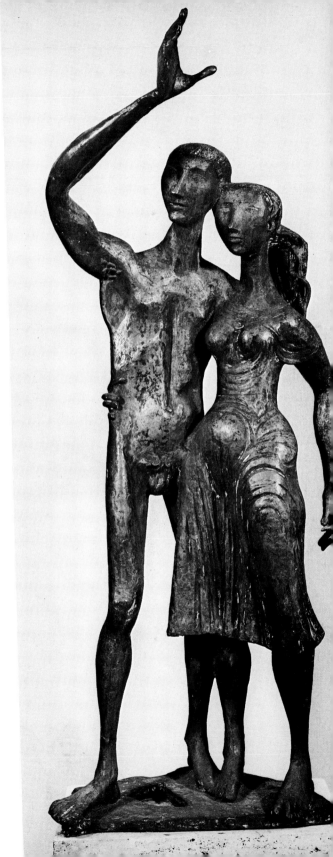

in the studio from sunrise to twilight. The American Academy is high on the Janiculum hill, with a beautiful view of the city. At the foot of the hill is the large working-class district of Trastevere, where there is always a lot of action in the streets. Hebald's first draped figure was "Girl of Trastevere," and there were many to follow. Numerous small bronzes flowed from his fingers out of the impact of Rome and of Rome's art: the "Rape of the Sabines" and assorted abductions, in very free interpretations; the marvelously cool and contained bronze variation on the famous Canova life-size marble of Pauline Buonaparte Borghese as Venus semi-recumbent. The ancient story about the piece has the princess's friends, somewhat shocked at the nudity and the transparency of what drapery there was, asking her, "But how did you feel, to be posing without any clothes on?" and Pauline, magnificently, replying, "Very cold."

Hebald's bronze Pauline has in it the quality of the anecdote, as well as the salute to a fellow sculptor, once the dominant artist of Rome, the creator of Neoclassic sculpture, now fallen into neglect.

WARRIOR. 12" high; 1957–1958.

PICADOR. 12" high; 1957.

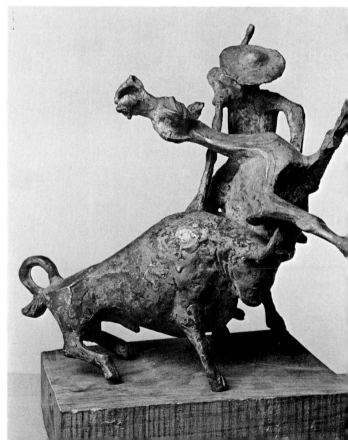

ETRUSCAN WARRIORS. 22″ high; 1959.

MUSIC. 18" high; 1958.

In those years at the Academy, Hebald fell in love with the past of sculpture as, perhaps, it is only possible to do in Rome and its surroundings.

"I got insight into the background of sculpture for the first time," he has testified. "I saw how sculpture fits into its environment. My point of view took a radical change." In America, before the war, Hebald had been accepted as part of the general social movement in art. Now he began relating his sculpture to the larger purposes, the broader nature of man in the world and to the ongoing tradition of sculpture from its distant beginnings in the eastern Mediterranean to the development of the Classical tradition in Greece and Rome, with side trips to the Etruscans and the great sculptural explosions of the Renaissance and the Baroque.

"It was a time of re-evaluation of my former aims. I saw at once that what I found in Italy was what I had been looking for—the protection given by

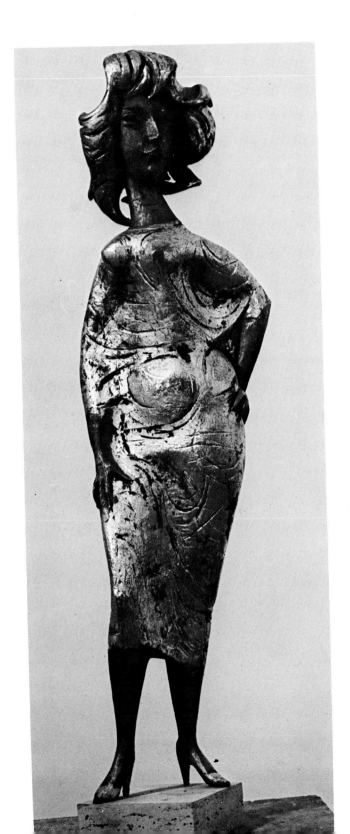

PRESSED FLOWER. 33½″ high; 1958.

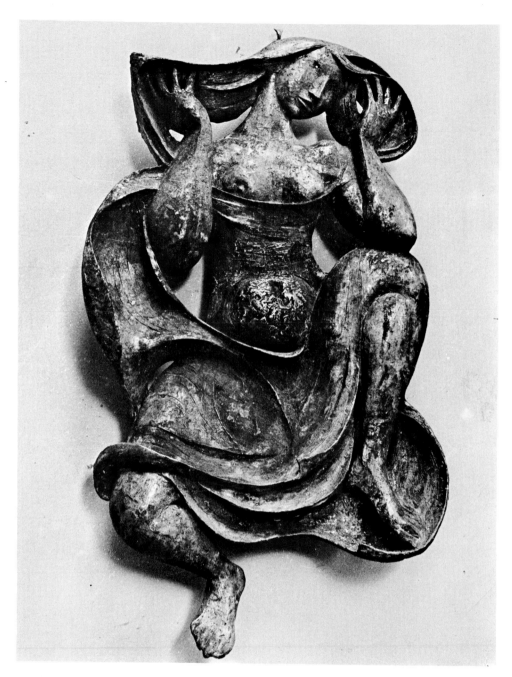

WOMAN WITH DRAPERY I. 39″ high; 1957.　　　*Opposite:* WOMAN WITH DRAPERY II. 37½″ high; 1960.

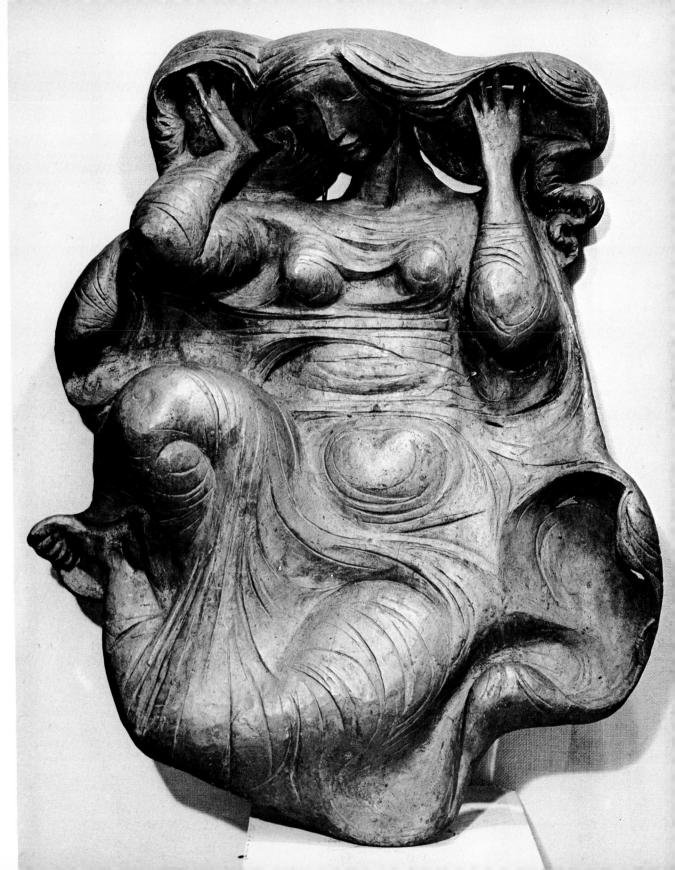

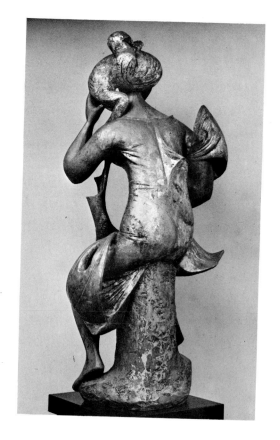

HOMAGE TO THE BAROQUE. 45″ high; 1958.

tradition, if you want to call it that. I wanted to find the real answers. I felt reinforced by being part of a continuous development from the past.''

From this exploration and sympathy for the past of sculpture came ''Raccòlta'' (''Harvest''), and ''Homage to the Baroque,'' a clear statement of the young American's identification with his Roman past. ''Harvest'' celebrates the harvest of human love in the human child. The beauty of the piece is in the marvelous swinging lines and enclosed spaces. This rhythm of the relationships of the forms and their spaces is mapped out in the lines of the mother's body showing through her dress. The spaces themselves are bounded in every case by complex curves rather than by straight lines. The curve of the overhead branch is reversed in the curve of the child's leg. The curve of the woman's arm meeting the hem of her skirt is smoothed and made solid in the rich swell of her hip. And all these curving, swelling forms and spaces are contained in essence in the lines inscribed upon the woman's belly and thighs, skirt and bodice.

36

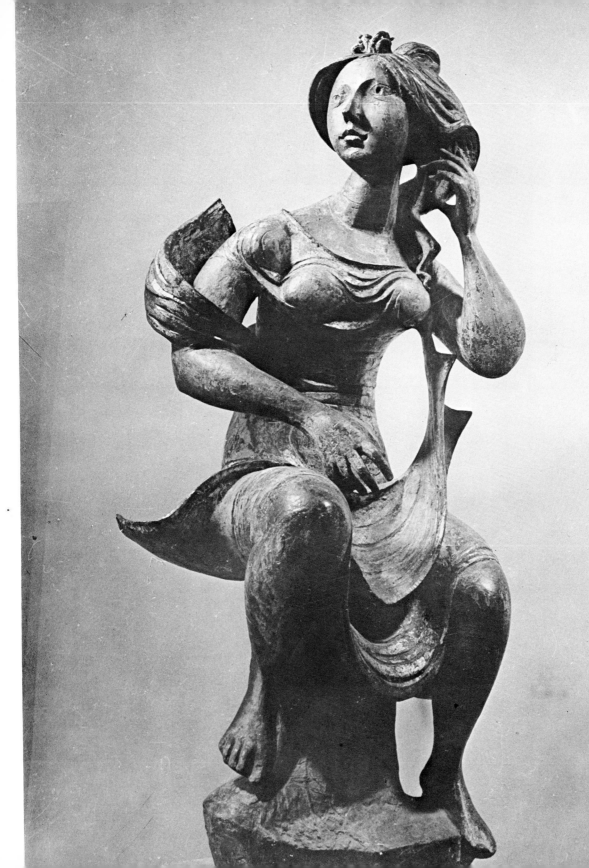

"Harvest," however, although a complex and therefore Baroque system of curves and spaces, is spread out. That is, the action of the mass starts at the ground and goes directly up into the air like a skyrocket, along the left side of the woman's body in as close an approximation of a sustained straight line as the piece possesses. At the top that upthrust line meets the intersecting curve of the branch, and all the forces swing rhythmically back to earth in the curves.

In "Homage to the Baroque," appropriately enough, the system is more compressed. There is no simple, one-line eruption from the earth to balance

SPHINX. 13½" high; 1959.

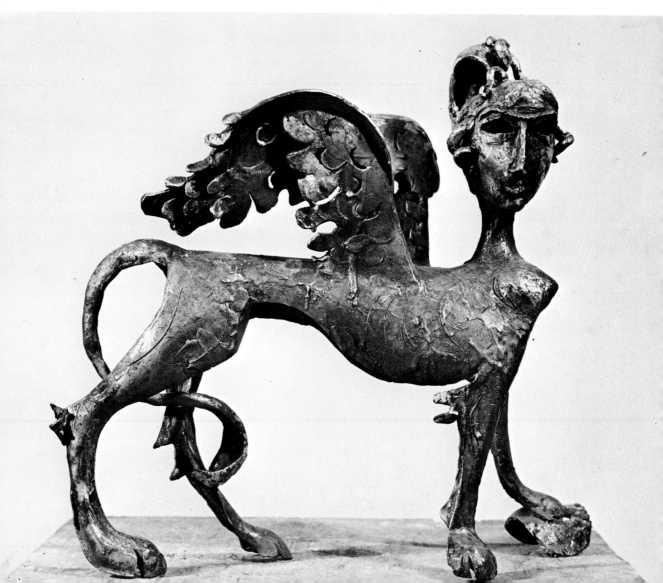

TRYST. 35″ high; 1964.

ALONG THE TIBER. Life-size; wood; 1957–1958.

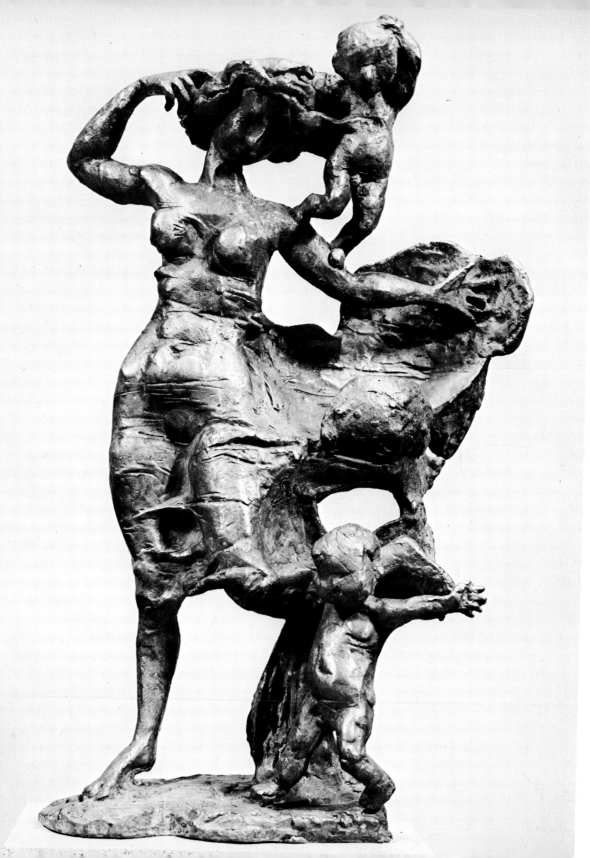

off the fountain effect of the falling curves. The figure closes in upon itself from all directions simultaneously, and yet reveals from every point of view a changing, related, opening out of spaces.

The inscribed lines on the body are more subtle than in "Harvest," but they are present and indeed continue in many of Hebald's later works. Here they seem much more identified with the natural folds of drapery over flesh, but in fact the flesh itself comes through the drapery at a number of crucial areas, most notably in the rounded belly. Folds of fabric swoop over the breasts and are repeated, on a larger scale, in the panel hung from the bodice, the stolelike piece around the right arm, in the airy, easy flight of the skirt, and in the coil of hair on the head, a coil that repeats itself in miniature in the topknot.

Surmounting the elaborate system of involutions is the calm and intent face of the girl. She seems to be listening to some distant sound, and from certain angles the hair she holds in her hand seems momentarily to be a shell held to her ear to hear the sound of the sea. She is Miranda all over again and in anticipation. She is also, perhaps, the spirit of the sculptor himself, engrossed, attentive, rapt in the vision of Baroque as revealed in Rome.

More than a walking tour of Rome in Hebald's company—and that's saying a lot—the two pieces show magnificently the unfolding of Rome's Baroque to the American sculptor and the counterpoint unfolding of his own Baroque in his own sculptural achievement.

Hebald has wanted to do as much as can be done in sculpture. The passion of some of his younger countrymen to do as little as possible is simply beyond his grasp.

The situation at the Academy was too good to be true indefinitely. Indeed, it was not designed to last. While it did, the Hebalds lived there in a spacious one-room apartment, with little Margo next door. They took their meals in common with the residents and were well looked after by the staff; Milton was provided with a studio and materials and an allowance. He flowered.

Edith Halpert, the monument of dealers in twentieth-century American art, came through Rome and bought five or six Hebald pieces for a show of young Americans working in Europe. In New York they sold quickly, and she asked for more. Hebald proposed a permanent relationship, but Mrs. Halpert was then engaged in paring down her representation to Americans

A CLODIAN. 19" high; 1963.

of an earlier generation: Zorach, Shahn, Weber, Sheeler, O'Keeffe, Marin—the classics. She recommended Lee Nordness, who had just opened a gallery under his own name, and Hebald has been there ever since.

As the two-year stay at the Academy was coming to a close, Hebald was asked by Prokosch to serve as a consultant for the new Pan American terminal building at Idlewild Airport, now John F. Kennedy International Airport. The architect was planning an "air curtain" for the entrance, and he needed some sort of mask. The solution, suggested by Hebald, was a glass screen bearing sculptured forms of the signs of the zodiac, which, on a celestial map, traces the same far-ranging arc from one end of the heavens to the other that is traced, on a somewhat smaller scale, by the flights of Pan American. The eventual choice for the job turned out to be Hebald. This major commission, as much as anything, determined his permanent residence in Rome.

The foundry facilities in Rome are magnificent from the point of view of a bronze sculptor. The United States had one, perhaps two, first-rate bronze foundries available to the sculptor and familiar with sculptural problems —significantly different from those of airplane or marine parts. Trained and highly skilled foundrymen work in half a dozen of the major Italian cities and in numerous small towns. In Rome alone, Hebald uses the services of three or four foundries in different parts of town, including one on the street of his studio, Via degli Orti d'Alibert, a kind of expanded alley that goes up from the wall of the Tiber to a dead end at the foot of the Janiculum. Most of his work is cast at the Nicci Foundry in Rome. The large, seated figure of Joyce was cast at Vincigliata Castello. This huge, late-medieval castle, high above Florence on the road past I Tatti, has been made into a foundry by its owner, a sculptor himself, the Israeli Gideon Graetz.

Hebald's neighbors on the Via degli Orti d'Alibert include a maker of beach and café umbrellas, a repoussé metal worker, the foundry mentioned, a plaster-casting shop, which Hebald also uses on occasion, a wood carver, an artist or two, and assorted other craftsmen. All of these neighbors understand Hebald's existence and profession. What he is doing is accepted as a profession and one to be respected. This is a general Italian attitude that Hebald finds immensely gratifying. Around Rome, he has pointed out, not just Michelangelo but Bernini, Caravaggio, Canova, and the rest of the golden horde of painters and sculptors are names with real meaning for

CORNUCOPIA. 27" high; 1964.

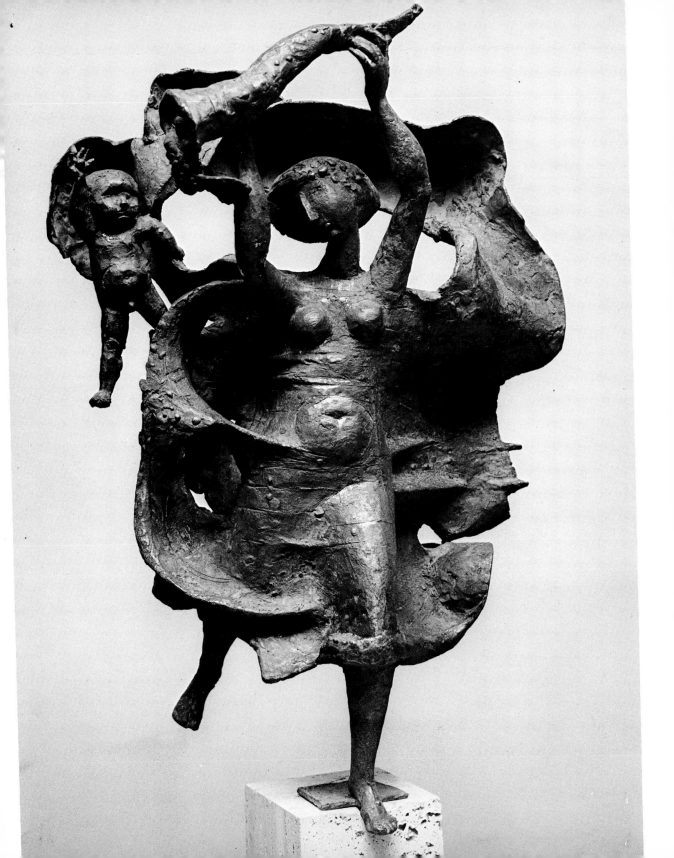

most people. Out of that background, Italians understand the existence and the trade of artists in a way not to be found in America, even among the museum crowd.

The Hebalds, after the Pan American commission, found an apartment in Trastevere, seven stories up, with a large terrace and window views in three directions. The studio in the Via degli Orti d'Alibert has an enclosed garden as big again as the interior, in which, in fine weather, Hebald works and in which he places pieces in progress to see them in the light. The Hebalds also acquired a piece of land near Lake Bracciano before the recent rise in prices, and on it they now have a house-studio with sculptural facilities designed in and with an opening view of the lake.

Like Browning, Hebald can be up at a villa or down in the city with little preparation. And like Browning, he continues to be fascinated with the Italian spirit, the Italian language and character, the Italian artistic past, which seems to blend into and support his own professional present and future.

3

In sculpture especially, the limits of a man's art are often defined by the literal limits of dimension: the big and the small. Cellini, for instance, was at the top of his form both when he created the exquisite saltcellar, in Vienna, and when he carved the austere and perfect life-size corpus, in the Escorial. Dürer, in contrast, was essentially a "small" artist, a print-man. He achieved monumentality—as in the "Triumphal Car" of the emperor —by adding small piece to small piece. It was a process of addition, like the monumentality of a freight train.

Hebald for years has, like Cellini, managed to work both sides of the street on that question. He grew up, professionally, in a decade when monumentality and public communication were very much on the minds of artists. Several turning points in his life were marked by monumental commissions. Moreover, he has long made it a habit of working a conception through a whole series of scales, from diminutive to something approaching the monumental, or at least life- or heroic-size.

Because of this, the question of size does not figure importantly in a consideration of his work. The same qualities are present whatever the size. This is readily evident in a detailed examination of his monumental works along with his "mini-works," as Hebald's "variables" might now be called.

The first variables go back to 1940 and to the year of Hebald's military service. In terms of the development of an artist, they are notable for two things. They are completely divorced from the ideas of social significance that were seen in his prewar work and they all represent a flinging forward into open spaces, a prefiguring of the Baroque that was to play such a great part in the work of the mature Hebald in Rome.

John Morse, in a *Magazine of Art* article in 1944, called Hebald's variables "Sculpture to Play With." All are ingeniously designed so that the parts can be moved around into variable positions in relation to one another. "Trapeze" features three acrobats and a stripped-down system of wires or bars upon which the figures may be placed. The figures are arched in the back, spread in the legs, and grasping in the hands, so that they may come in contact with the bars in several positions. They can hang down or thrust up, suspend from a horizontal bar by the knees or from a vertical bar by either hand in either a heads-up or heads-down position. Multiply the variations by the three figures and again by the bars and wires and you have a large number of combinations and permutations. You also have a large number of space relationships that change as the figures are changed, much as the spaces and volumes in an elaborate Baroque statuary group change as the observer walks around it and through it. The figures are the stripped-down, stylized figures that Hebald had been doing before the war, but their acrobatic tensing and their variability of position brought them into the Baroque dimension of sculpture in a way that had not yet appeared in other Hebald work.

"Jungle Gym," of 1946, uses five variable figures of children at play against the rigid grid of the popular playground fixture. The diminutive figures can go heads up or heads down or sideways. There are eighteen spaces—more or less cubes—for them to inhabit, plus the pedestal. It is not necessary to stress the emerging feeling for Baroque solutions and accomplishments in Hebald's sculpture, but it can be noted that the form of the jungle gym itself —about as anti-Baroque a structure as there is—is pushed a little in that direction by the sculptor's breaking from true verticality in the uprights and having them thrust out as they thrust up. In its own modest scale, this is the playground equivalent of the Baroque bursting open of the Renaissance columned façade.

The difference of five years—and Rome—can be seen at a glance in the two versions of "Bull Dogger," 1950. (The second version, "Throwing the Bull," is illustrated.) Perhaps only Hebald, an American sculptor in Rome, could perceive that a cowboy is essentially a Baroque figure—in costume, in gait, in pose and repose. He is so revealed in both these variables. The bull, too, is at once the familiar antagonist of the rodeo and the ancient, timeless bull of the Mediterranean, from Crete to Spain.

IL RATTO D'ITALIA. 13″ high; 1957.

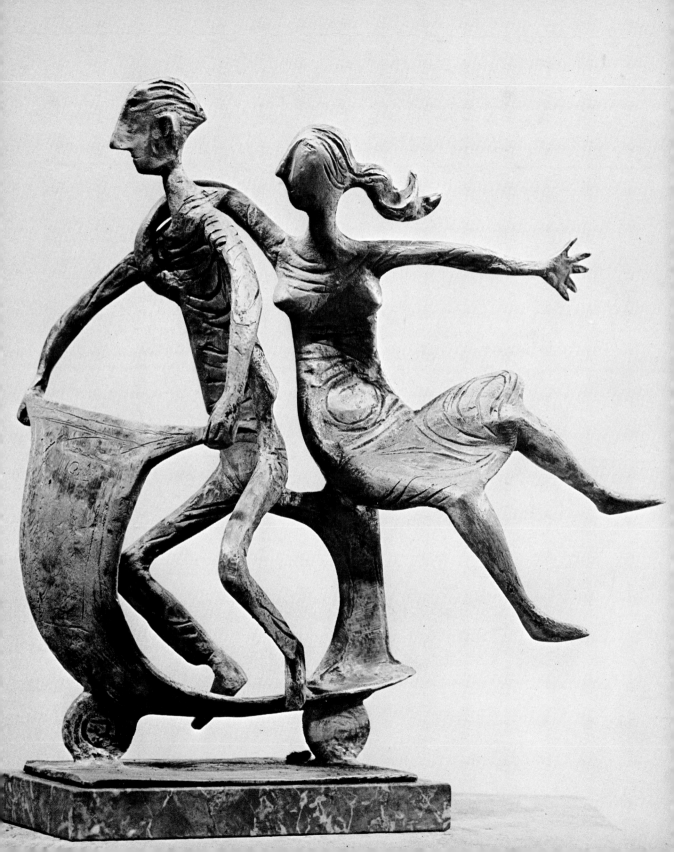

THROWING THE BULL. 10″ high; 1950. *Opposite:* HIM TO THE GREAT SPIRIT. 21″ high; 1959.

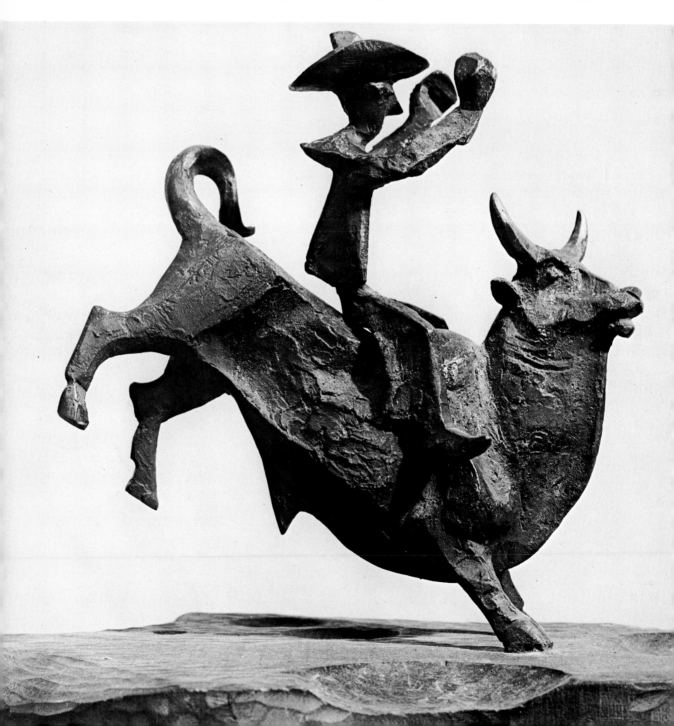

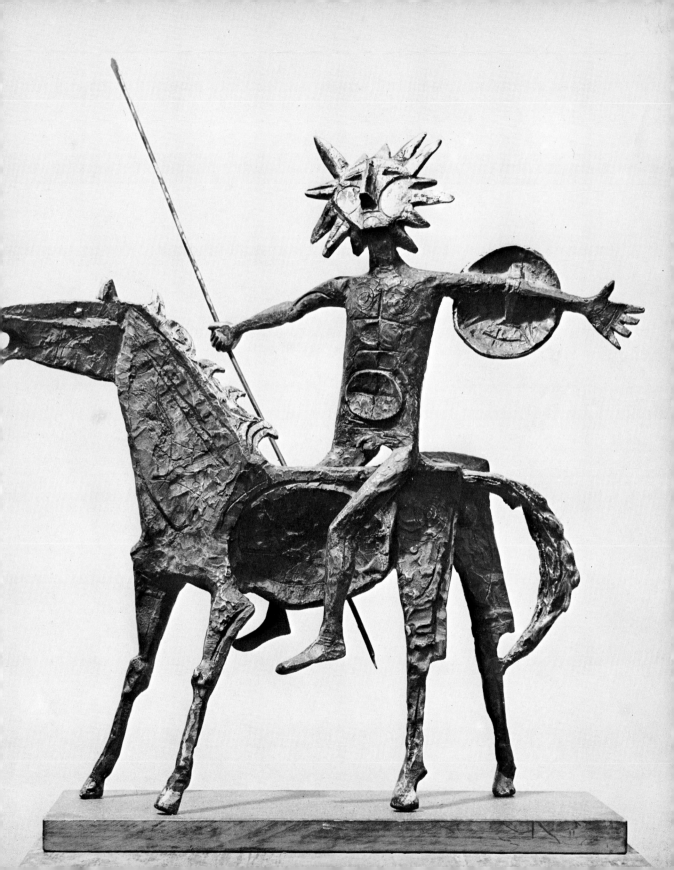

BATHERS. 4″
high x 12″; 1963.

Lately Hebald has taken up variables again. There is a group made to swing in the wind and play chimes when they collide. There is a rock-dance group that's ecstatic. Returning, as always, to one constant theme, that of man and woman, there is a lovely and amusing variable called "Couple," a punning title. The small figures are much more free and wavy in their long bodies than any of the earlier variables, and the man and woman couple in many positions. She floats horizontally against his vertical stand as if in levitation; the couple stand facing each other, curving in unison, she back, he forward; he lifts her by the hips from behind, as if in acrobatic display; he holds her, head down, in a later stage of acrobatics; and, of course, they recline, curve to curve, convex to concave, face to face, or reversed. The variations seem infinite.

A certain amount of Hebald's mastery of the figure has come out of the variables, and some of his large groups are made in a way that would not have been conceived without this earlier experience. Consider two:

BATHTUB BOX. 5¼″ high x 13¼″; 1963.

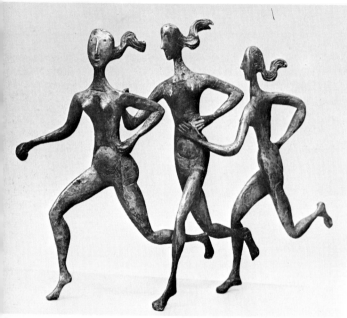

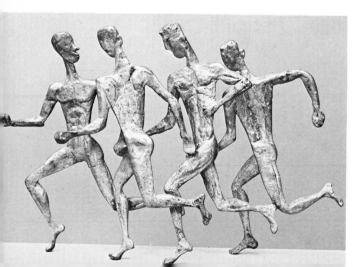

Top: BURLESQUE. 23" high; 1967.

Center: 500 METERS. 14" x 20"; 1962.

Left: 5000 METERS. 14" high; 1961.

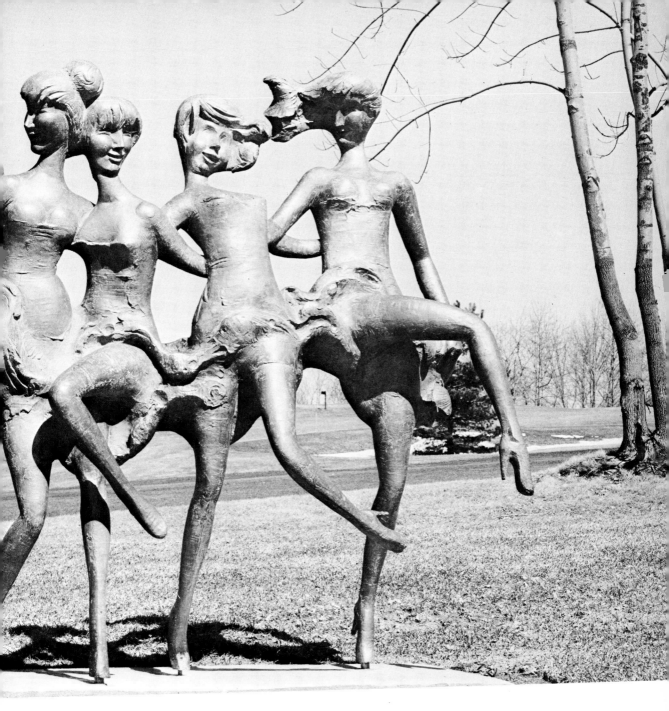

CANCAN. 78″ high x 84″; 1969.

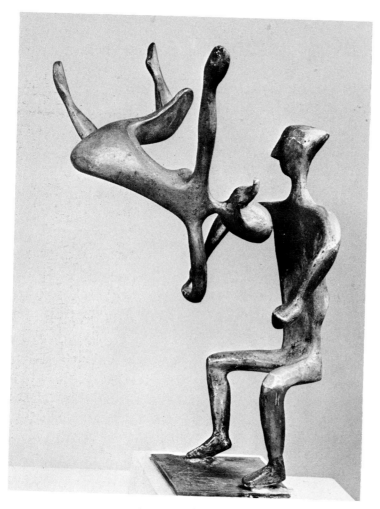

JITTERBUGS. 11″ high; 1957.

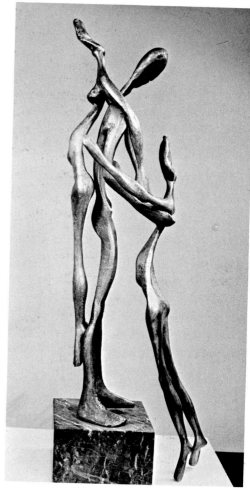

TRIPTYCH. 17″ high; 1967.

The 1957 "Il Ratto d'Italia" reveals its debt at once in the open curves, the air of the relationships among the boy, the girl, and the motor scooter being momentary: they could all change at any moment. The piece is historically documentary, in addition to its other virtues, and, as so often, the title—and more than the title, the concept—is a pun. In art, of course, *il ratto,* or "rape," usually refers to the act of abduction rather than to that of copulation, except in such down-to-earth realists as Callot. Like Europa

FRUG GROUPS. 17″ high; 1967.

being carried off on the broad back of Jupiter as a bull, here the girl is carried off by the boy on a Lambretta. More than that, many Italian urban residents in the late 1950s were convinced that the motor scooter was the olfactory, acoustical, and pedestrian rape of the country. Since then the small Fiat has replaced the scooter and the streets are a little quieter, but "Il Ratto d'Italia" combines a moment of recent history with a whole tradition of historical painting and sculpture.

CONVERSATION. 9" high x 26½" x 22"; 1967.

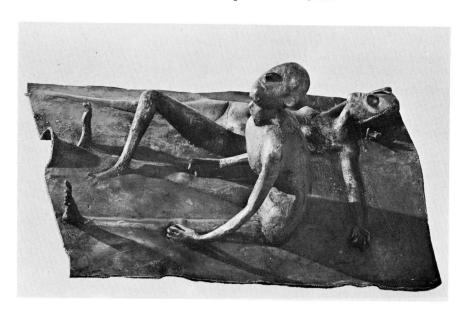

TIDE IN. 12½" high x 20" x 26"; 1967.

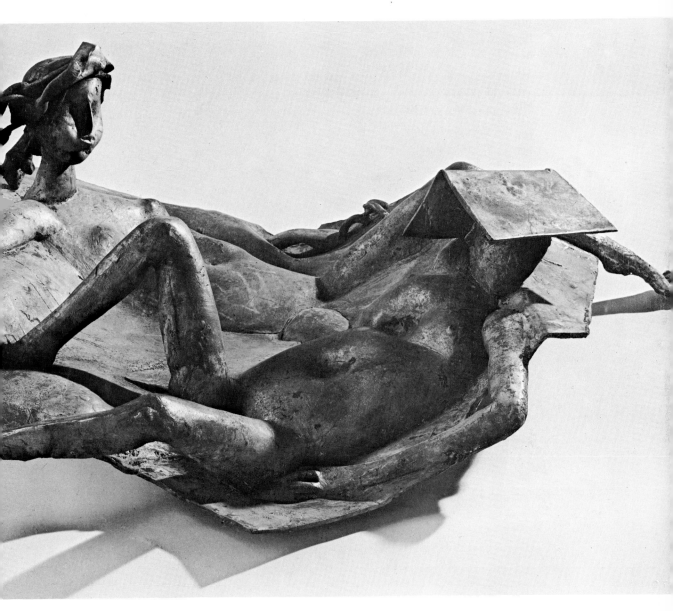

DAILY NEWS. 9″ high x 26″ x 20″; 1967.

The second such piece is the 1959 "Etruscan Warriors." Again, one has the feeling that the two warriors could be in several other positions in relation to each other. The sinuous grace of both the "Ratto" and the "Couple" is deliberately missing. Instead, the stiff, awkward arms and legs capture something of the stiffness of Etruscan art itself, the tomb paintings and the effigy figures to be seen in and around Tarquinia. The helmet with the nose guard is a tribute to the Metropolitan of Hebald's childhood, where the presiding deity for many visitors to the museum in those days was the heroic-size "Etruscan Warrior" in terra cotta, since proved to be circa 1912 and, mistakenly in the opinion of most sensible people, retired from view. Etruscan art is one of numerous areas in which the Hebalds have acquired a certain amount of expertise since living in Italy. The "Warriors" expresses something of the contrast between the Etruscans and their Roman successors without even showing the total efficiency of the battle style of the Romans. The two soldiers clearly demonstrate that military finesse was no essential part of the Etruscan way of life. Clumsy, awkward, sticklike, the two warriors seem to be on the verge of knocking each other over, like a couple of White Knights from *Alice*. This is a fair interpretation of their history to anyone who knows the tomb murals and the effigy figures: the Etruscans, by those records—and there are very few others—were a joyous, peaceful folk with some Greek trade connections in their background, and too sensible, in all probability, to be much good at the craft of war, which the Romans made into an art and an empire.

4

Before his Italian period, Hebald's outstanding achievement in public monumental sculpture was the bronze figure group for the façade of the Nathan B. Van Etten Hospital in the Bronx. He discovered at once the architectural relationship he was to use often in public statuary, namely very little. The figures themselves are not especially affected by Hebald's interest in the Baroque, but note the sculptor's use of the space around them. The great expanse of brick is empty space for the family group. There is also space between the family members. They are not a cohesive, together group of the kind that Hebald has made so often; the space around them is echoed by the space among them. They are in the act of coming together, after apartness. This is obviously the pleasantest part of a stay in the hospital, but that selected moment also sums up the aspiration of the whole profession of healing, the process of healing so to treat the injured member that he is no longer isolated for cure but can again become a member of a larger social unit, and most particularly of the family as an active, associating, mutually helping group. The postures and the expressions of the four figures all say this very clearly, but the delicacy and the poignancy of that critical moment in the house of healing is stated most eloquently and subtly in the spaces, both around the group and within it.

Interestingly, Hebald made a similar use of open space during that same year, in an entirely different medium for a client who was responsible for his most impressive monument to date, Walter Prokosch the architect. For his home in Old Greenwich, Connecticut, Hebald created three fantastic beasts in enameled copper—the sphinx, the griffin, and the dodo—and placed

them over the mantelpiece in a spatial arrangement that has the vanished dodo and the fabulous griffin confronting the lip-sealed, silent sphinx.

The zodiac group for the Pan American terminal at the Kennedy airport is Hebald's most expansive public sculptural group so far and undoubtedly

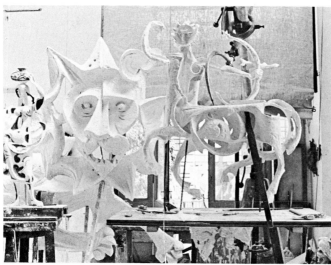

ZODIAC SCREEN (in preparation).

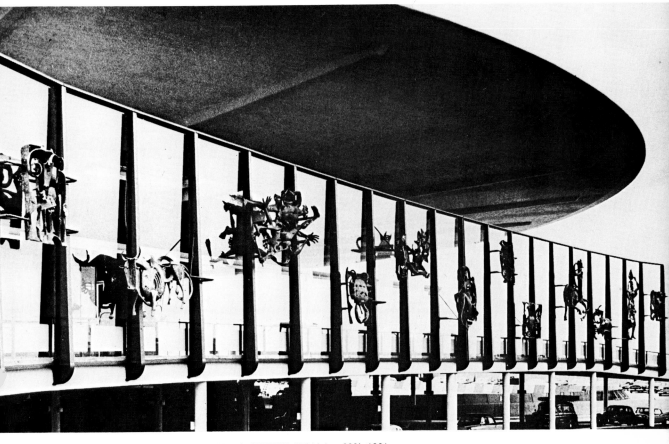

ZODIAC SCREEN. 25' high x 220'; 1961.

the one seen by the most people. It is, in an odd way, a mid-twentieth-century equivalent of Bartholdi's Statue of Liberty in New York Harbor. Like "Liberty," Hebald's "Zodiac" is the first sculptural expression of America that many foreigners see. It is also the parting view for Americans as well.

The differences between the two works are as profound as those between the situation occupied by America then and the one she holds now. The zodiac as a symbol is timeless. Those fabulous beasts and persons divide the year and the "great year" and the slow, galactic turning of the universe itself. The band of the zodiac was discerned across the starry night by ancient astronomers, when its glittering points were assumed to be tiny adornments of the great earth. It may still be seen from tiny earth, across literally unimaginable gulfs of intervening space. The destinies of men and nations,

VIRGO. 8′ high; 1960. GEMINI. 14′ wide; 1960.

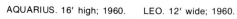

AQUARIUS. 16′ high; 1960. LEO. 12′ wide; 1960.

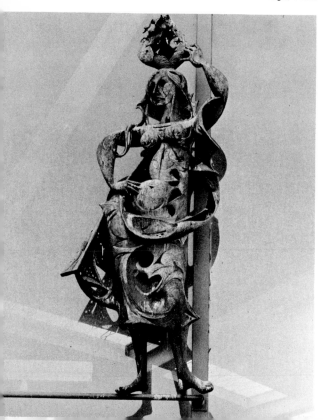

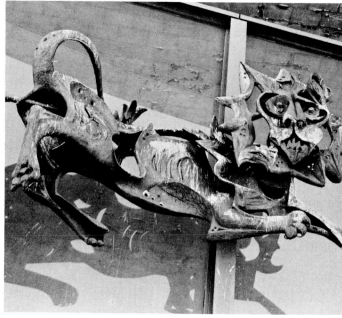

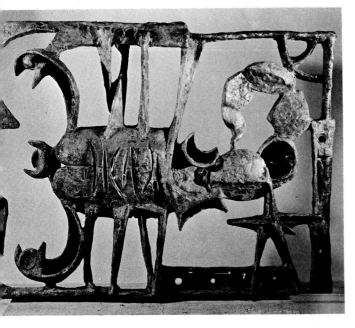

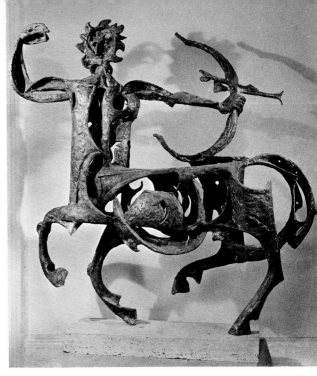

SCORPIO (MODEL). 21″ x 25″; 1957–1958. SAGITTARIUS (MODEL). 40″ x 33″; 1957–1958.

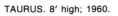

TAURUS. 8′ high; 1960. ARIES. 13′ wide; 1960.

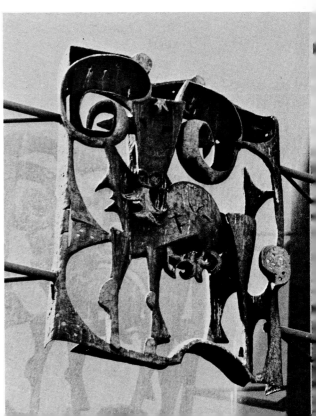

of the gods themselves, have long been thought to be determined by the conjunctions and separations of the mythic beasts and people of the sky. From a purely astronomical point of view, the discernment of the zodiacal signs was the beginning of the discernment of order in the universe. It is by the knowledge of such order that the globe is circumnavigated, whether by sea or air. If Bartholdi's great lady in the harbor was a sign of America's free welcome to all the nations, Hebald's beasts and persons at Kennedy are a sign of American unity not only with the nations of the globe as now constituted but with the peoples of human history entire, all of whom have looked to the heavens for the controlling movements of the zodiacal figures Hebald has set in bronze at an American gateway.

The glass screen that holds the figures is two hundred and twenty feet long by twenty-five feet high. The figures are correspondingly sized. Sagittarius, for example, the centaur-archer, is twelve by twelve feet in height and length.

Neither the orrery nor the celestial globe nor any other device made for the purpose has ever succeeded in conveying the depths and complexities of galactic space: there's too much of it; the distances are too great; there are too many points.

Nevertheless, Hebald's "Zodiac" across the front of the Pan American terminal building does achieve some degree of feeling for such space and for such ordering of space as the zodiac represented to those remote ancestors of ours who first discerned it. The terminal itself is a great flat circle, with its broad roof stretching out like a total eave over the facilities of arrival and departure. Girder beams support the roof like so many abstract marks on a sidereal clockface. Intersecting this circle is the vertical wall of glass upon which the zodiac figures are mounted, broken by girders into twenty glass panels. The screen is not in one plane, but curves very slightly. The curve is actually that of the roadway and walkway, but in this context it suggests that it is part of an immensely larger circle intersecting the finite circle of the roof. Upon this immense circle, in similarly measured spaces, stand the bronze signs of the pathway of the stars, of fate, of eternal voyaging across the universe.

The figures themselves have more than a suggestion of the archaic in them, although it is a wholly original archaic quality. They look as if they had lived long in the bottomless seas of space and there undergone sea

CRUCIFIXION. 27" high; plaster; 1960–1961.

64

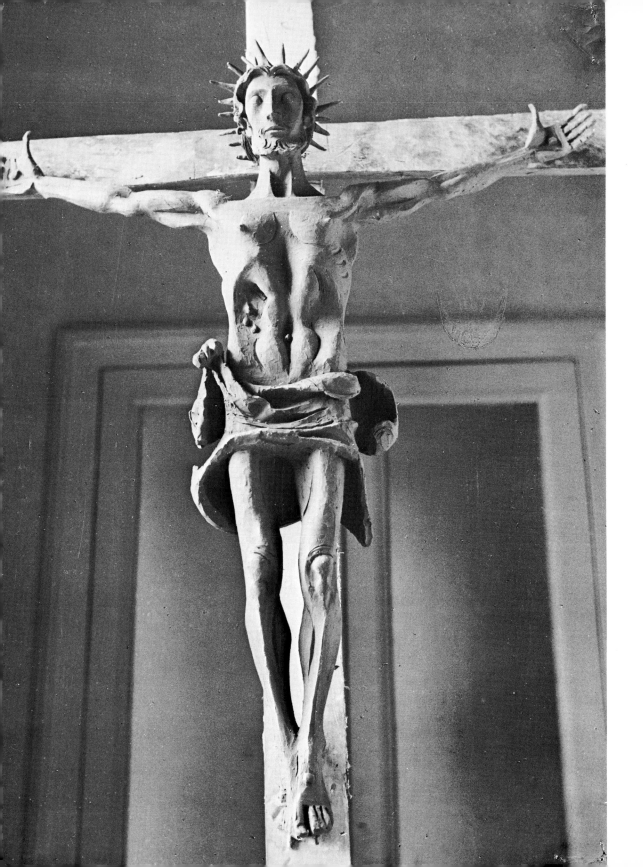

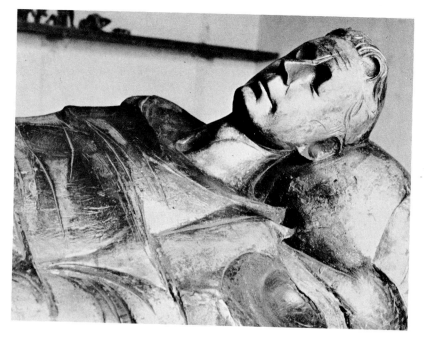

changes of encrustation. Although fixed to a wall, each creature of "Zodiac" has a back as well as a front. The smaller versions, owned by Senator William Benton, allow the viewer to see the whole series much more readily than he can at the airway building. But the airport experience is stronger in its architectural, spatial dimension. We embark or return from a journey under the sign of some ancient, improbable, yet finally compelling guardian from the cosmos.

In 1965 Hebald was commissioned by the New York City Department of Public Works to do two bas-reliefs for the entrance to the new Queens Central Public Library in Jamaica. There are two groups of figures. At the left of the entrance is "Education," a mother reading to her boy and girl. At the right is "Youth Conquers Space," two young men with books and blueprints.

Both groups take some of their strength from the limitations of the bas-relief form. Hebald did not try to pass the figures off as full, in-the-round forms done flat. Rather, their acknowledged flatness accounts for their distinctive qualities. In the "Education" group, the mother almost suggests a flattened medieval form of a prophet reading, in which the flatness of the

page or the wall makes the painter spread out elements he knows to be not spread out. But Hebald infuses this flatness with a singular grace: we feel that the reader has for a moment laid down the book in her lap to savor a passage. This impression is underlined by the entranced quality of the boy and girl. The flatness of the bas-relief accounts for the twisting together of the legs of both children; yet in both cases this results in an authentic rendering of youthful concentration and a certain poignant striving quality in the relief.

The reader's hair, in a device Hebald invented several years earlier and uses fairly regularly, blends in, sculpturally, with the leaves and fruit of a background tree: she becomes part of the shelter for all three.

On the other side of the door, the overhead-shelter element is a bronze cloud of stars and planets, faintly recalling, here and there, the cosmic whirl of Van Gogh's "Starry Night." Beneath this shelter, which is also a challenge, the two youths stride forward and gaze intently. Any visitor to the subterranean sculpture chambers of the United States Capitol knows the extreme difficulty sculptors have with modern clothing. In terms of sculp-

WILLIAM HAYES ACKLAND MEMORIAL. 7′ wide; 1961.

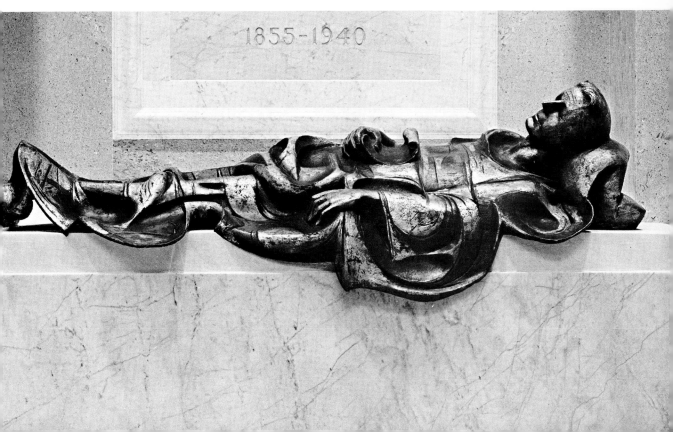

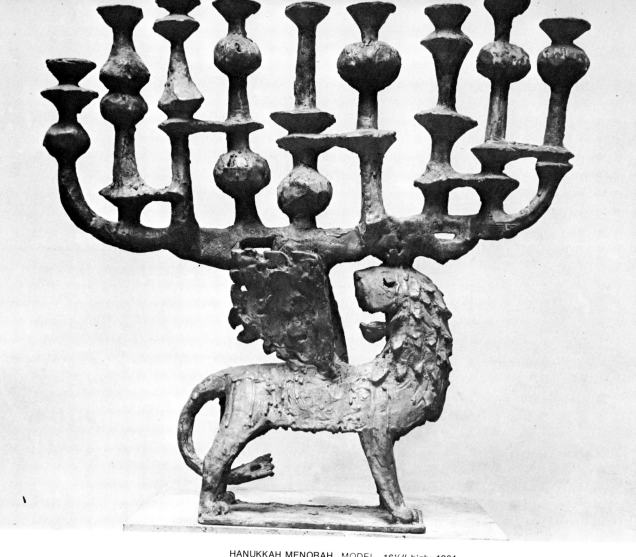

HANUKKAH MENORAH. MODEL 16½" high; 1964.

tural opportunity, a necktie is no ruff and a business suit is not in a class either with ecclesiastical robes or with the nude body. But here again Hebald has turned a handicap into a strength. The suited youths reveal a certain awkwardness in their determination which quite fits in with youthful aspiration. In this connection, there is, in the upper figure, a curious recollection of the stiffness of the "Etruscan Warriors."

In times past and especially in the Baroque period so greatly admired by Hebald, the monumental sculptor could count on the ecclesiastical establishment for many, perhaps the bulk, of his commissions, as walks in Italian

cities amply testify. Times have changed; today's churches tend either to buy their sculptural decorations ready-made from factories specializing in such bland productions or to have few or none at all.

Commissioned by the collector, Armand Erpf, Hebald in 1960 and 1961 modeled one of the few modern crucifixes with a real sense of religious and sculptural life. The life-size corpus combines the dignity of the subject with a profound sense of suffering translated into the sculptural concavities and muscular tensions of the arms and torso. The face stares blankly ahead, beyond pain. The crown of thorns has been made into a sculptural nimbus, an inspired solution to a small problem in adapting traditional iconography to contemporary situations. The crucifix, intended as a gift to the Catholic church in Margaretville, New York, was rejected by the pastor and has not yet been cast in bronze, thus showing that the church, striving to catch up with the twentieth century, still has some distance to go to overtake the sixteenth.

Hebald's Hanukkah Menorah, for the Adas Israel Congregation in Washington, D.C., has had a happier acceptance. The nine branches of the candelabra proper swell into bulbs and then into lozenges recalling both the Baroque and the timeless pottery of the ancient Middle East. The winged Lion of Judah, supporting the candelabra, is a fabulous beast in the best Hebald tradition, the curve of his tail matching the curve of his neck, and wings and body inscribed with markings that are at once hair and feathers and mysterious writing.

An almost unique assignment came to Hebald in 1961; a recumbent form for a sarcophagus. William Hayes Ackland, a Southern lawyer of wealth and distinction, died in 1940 and left his fortune to found an art center at the University of North Carolina in Chapel Hill. The bequest stipulated that the benefactor be interred at the entrance of the center beneath a traditional burial sculpture.

This form is virtually unknown in our time. Historically, of course, memorial effigies were customary among the Etruscans and the Romans, and in the medieval, Renaissance, and Baroque periods. Hebald, with his keen feeling for all those periods, could not have been better equipped for the task.

The university had originally ordered a marble tomb effigy from an Italian factory and got back a dead photographic image in white stone. Thinking better of it, they commissioned Hebald. There were difficulties. Ackland had died twenty years earlier, at the age of eighty-five. One friend survived, and

there was one photograph of the lawyer as a young man. Hebald, as it happens, is an extremely talented portrait sculptor when he chooses to be, but under the circumstances he chose instead to feature a minimum of portrait fidelity and a maximum of Baroque drapery as funereal expression.

In place, thanks to the drapery, the bronze figure seems to hover above the plain block of marble that is the tomb. As in the New Sacristy of San Lorenzo, we do not really know what degree of likeness Michelangelo gave the figures of the minor Medici dukes entombed there, so at Chapel Hill there is no one who really knows if the recumbent figure presents a good likeness of the donor in middle life, 1900 to 1920. But the generous spirit of William Hayes Ackland is well served in the flow and curve of the funereal cloths, at once somber and solemn and light and lifting. Bernini would have been well pleased with this flow of black bronze heightened by touches of gilt.

BURNING BUSH. 4′ high; beaten brass; 1969.

70

5

Bernini is perhaps most widely known today as the author of most of the favorite fountain sculpture in Rome. As with funereal sculpture, so with fountain sculpture: our century does not give the artist much opportunity. Still, Hebald has managed to make his own opportunities. The "Tempest" was conceived as a fountain for Central Park, to be placed near the area occupied by the summer Shakespeare Festival. The original plans fell through, but the work remains, in its several versions, a powerful interpretation of Shakespeare's vision and, in its watery suggestions, a superb example of what Hebald does in the spirit of the great fountains.

He has, in fact, expanded that spirit considerably. Hebald's sculpture in general is an intensely humanizing body of work. The Baroque fountains—Bernini's "Rivers," for instance—typically embodied some abstract idea in an ideal human form. Hebald has reversed the process. In his fountains he very often models mythic abstractions—Noah, Neptune, mermaids and Triton—into human personalities.

Hebald's humanism is expressed more directly in other fountains. "Joy of Life" uses the act of running, a motif Hebald became fascinated with at the Rome Olympics. The three figures—mother and children—race ecstatically into sunlight and, you feel as you look at them, over the low flow of water at the edge of a beach. Skirts and hair billow out in the wind. Arms and legs are flung happily forward.

The same kind of humanism informs the "Children at Play" fountain in the Solikoff Collection in New Jersey. Incidentally, the theme provides a handy measure of Hebald's increasing mastery of sculptural complexity while in Rome, for it compares with "Children's Games" of almost a decade earlier

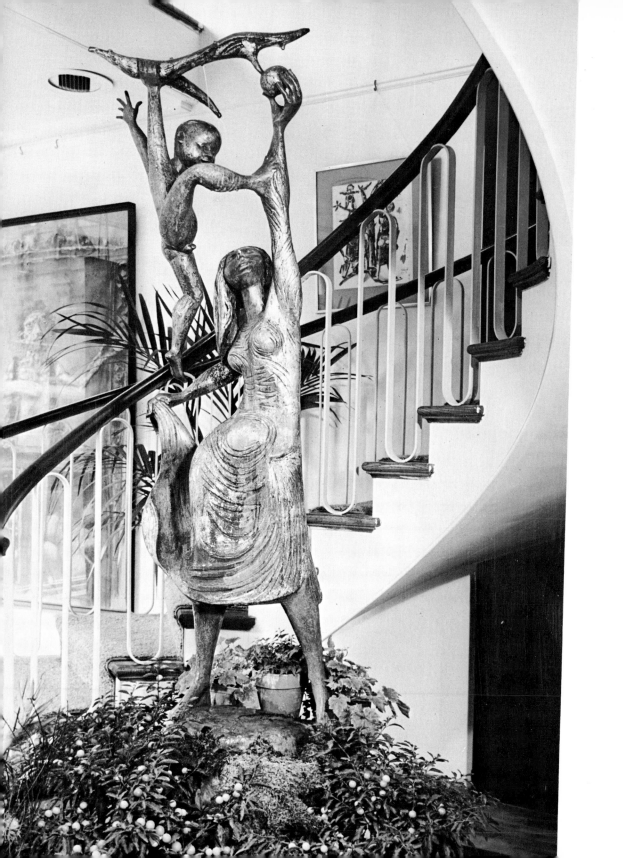

JOY OF LIFE (POMERANCE FOUNTAIN). 7' high; 1963.

CHILDREN AT PLAY. 5' high; 1961.

HARVEST. 66'' high; 1957.

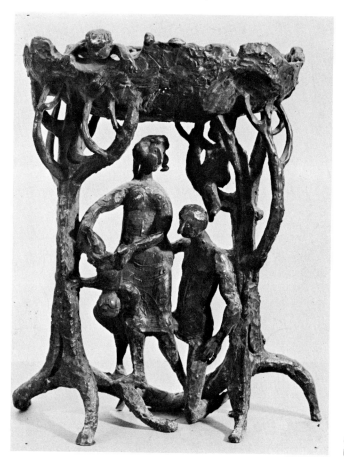

in New York. The New York sculpture is smaller and made of aluminum.
There is already an interweaving of the spaces and forms, one figure to the
next, between the girl and the boy, linked by the baby, and between the dog
and the handstander. But the conception as a whole is lineal. You can read
it from left to right; indeed, you are almost forced to read it from left to right.

The "Children at Play" fountain, made in 1956, shows three children and a
dog. Here again spaces and forms are intimately and intricately interrelated,
but now the interrelations move around the circle of the forms, across it,
and diagonally up and down. There is no one way to read the group. It is a
whole, accessible from any point, and from any point leading in to all the
other points. It is a superb realization of Hebald's constant ambition to pro-

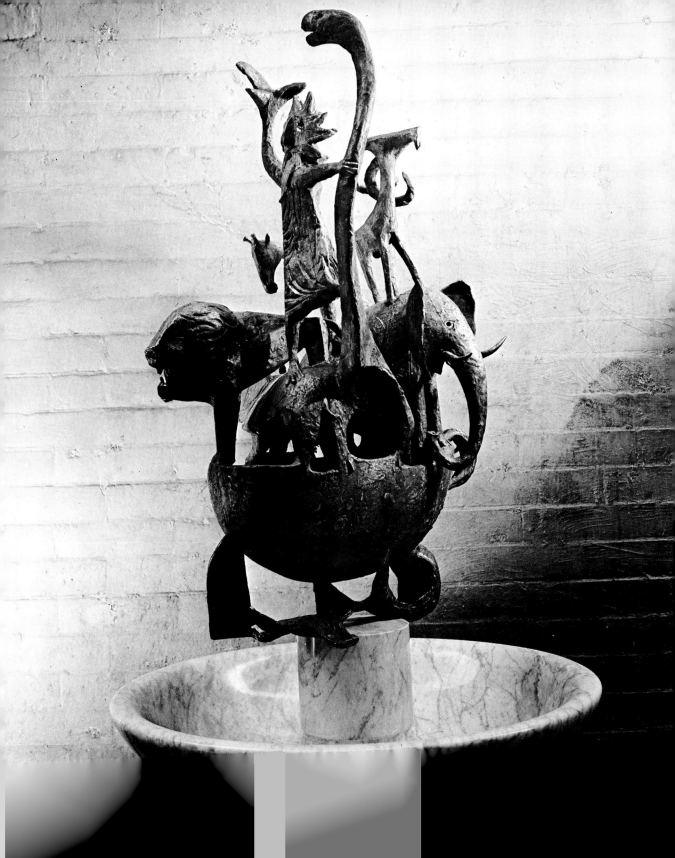

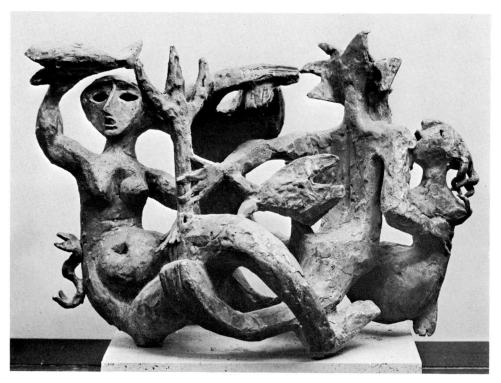

NEPTUNE STUDY. 12″ high; 1961.　　　　　　　　NEPTUNE FOUNTAIN. 9′ diameter; 1961.

duce a multitude of viewpoints, all of visual interest. The jets of water, arising from the surface of the pool, echo, in their casual arcs, the casualness of the curved spaces of the group. The water jets pierce the complex, three-dimensional form of the group much as the straightforward leap of the dog penetrates the group of three children.

"Noah's Ark," at The Prairie School, in Racine, Wisconsin, is another natural fountain subject, yet one which, as far as is known, was never executed by any of the great fountain sculptors of the past. For at least a century the subject has led another life in the popular imagination, derived from but distinct from the scriptural function of the saving of species. The Noah's Ark of the amusement park is a comical-chilly-scary journey through dark passages and tilted, crazy rooms. The Noah's Ark of the nursery is the classic collection of beasts for children, governed by Noah, who in turn is governed by Noah's wife.

76

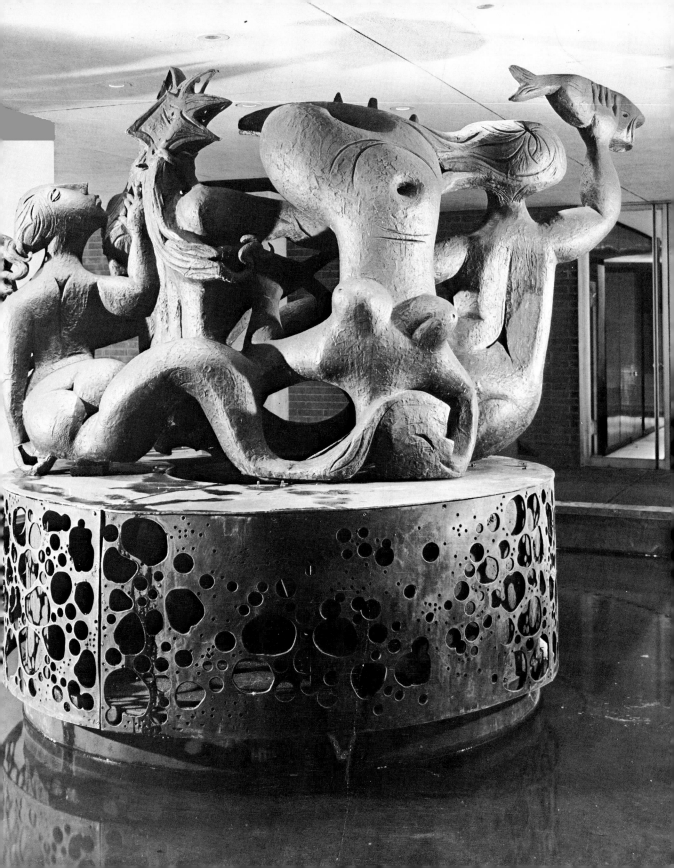

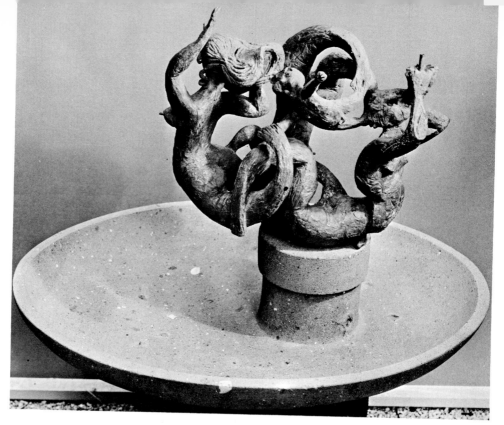

MERMAIDS AND TRITON. 24″ high; 1961.

Hebald has not attempted the full, nursery run of the animals, two by two. He suggests them by the exotics he has chosen: the long-necked giraffe, the marvelously horned ram, and the hulking rhinoceros. The bulk of the beasts is supported by the rounded bulk of the ark itself below. In the midst of all these curved and complex forms, Noah, venerable, hoary, crusted, rears himself upright to launch the dove of peace almost as if the bird were a child's paper airplane. The aged prophet, thrusting his way through his huge charges to the sun and air and the future of the world, is similar to Prospero raising his arm to raise the tempest. Great forces, in both works, are being commanded by man, but the man, in both works, is utterly human, complete with the ragged edges of rough-hewn humanity.

The relatively small—twenty-inch-high—"Pastoral Fountain" (1960) places children above the couple and their infant. The billowing forms of the trees overhead serve the place of clouds in a Baroque conception, and like those clouds they are inhabited by cherubs or children. The tree-fountain idea recalls a conceit Hebald has never seen, the "Raining Tree" in the garden of the Summer Palace outside Leningrad.

In three rather special waterworks, Hebald summarized his ideas of water as a sculptural medium in connection with the complexity he has inherited from the Baroque. The "Mermaids and Triton" of 1961 is endlessly curved in upon itself. Triton rises from the depth to blow upon his conch shell, out of which water spurts. The mermaids spew forth water jets from a classical Baroque source, the nipples of their breasts. The central mermaid manages to be both mermaid and shapely woman, for her legs retain their separateness even while taking on the suppleness of the dolphin or eel. The whole conception is an entirely successful effort to show what infinite grace we humans could display had our evolutionary path come out of the fish world instead of the world of apes and monkeys.

The same year saw the creation of the "Neptune" fountain for the court-yard of the apartment house at 333 East 79th Street, New York, designed by the architect, A. W. Geller. Again the bodies are sea forms; again they turn back upon one another and upon themselves like the eddy of water currents. Neptune presides in his watery court, his crown indistinguishable from his hair, his trident firmly planted on the sea floor and at the same time in-extricably mixed up in the sinuous thighs of the mermaid who reaches up to

UNDERWATER FOUNTAIN. 17″ x 33″; 1963.

catch a fish, which, thus squeezed, spurts a stream of water out of its mouth. Meanwhile, Neptune's other hand spreads broadly over the midsection of the second mermaid, who turns her pouting, spouting lips upward toward his. Hair floats in the deep; a fantastic fish gulps along at Neptune's back. The sea god's tail, like the base of his trident, finds its serpentine way to the twisting thighs of the fish-catching mermaid, out of sight of the maid whose waist he holds.

In 1963 Hebald produced a unique piece of water sculpture, which he designed to be underwater. The usual fountain gets its movement from water moving through air. This one, in the Boscowitz Collection, in New York, reverses the process. Jets of air bubble through the figures as they swim eternally through the currents. As with "Neptune," one male figure pursues two females. All three course through the water, passing vegetation growing from the ocean bed—twisting through it, indeed, almost in the manner of the ski slalom. The feet of the swimmers sprout flippers, but there is no line of demarcation between foot and flipper. Like the mermaids, the swimming girls are turning slowly into fish forms. Bernini's "Apollo and Daphne" at the Borghese Gallery in Rome has long been the envy and admiration of Hebald. Here there is something of a memory of that great work. The sea plants rising from the floor are like the laurel tree in texture. There is a pursuit—although of two young women, not one. And there is a metamorphosis.

GREAT FORTUNE. 78" high; 1967.

80

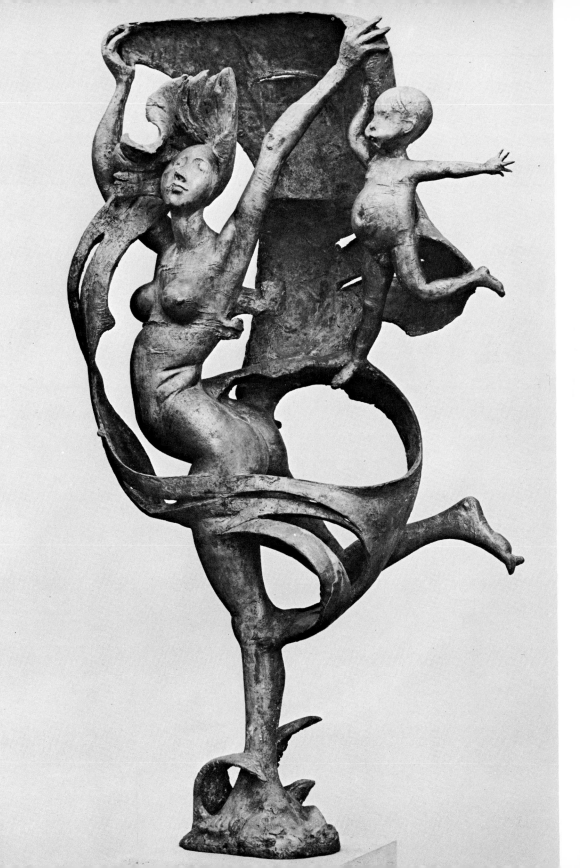

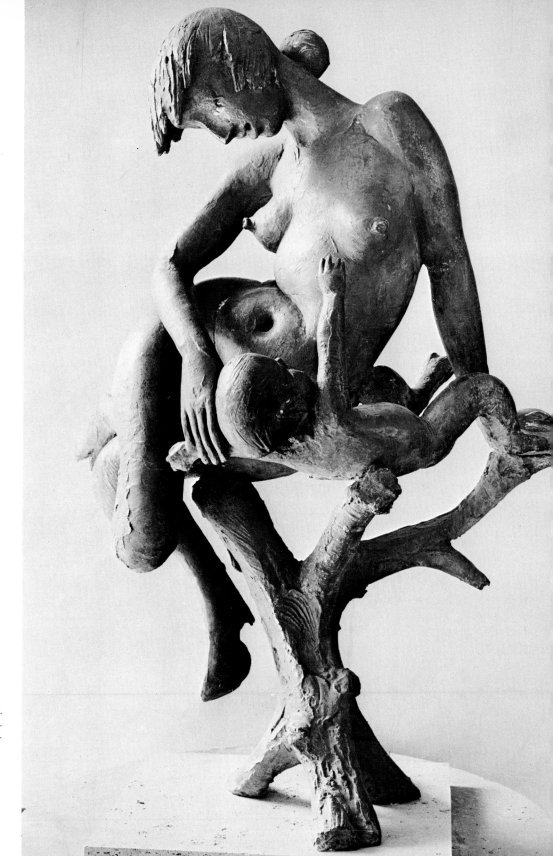

FAUN MOTHER.
48'' high; 1969.
In two views.

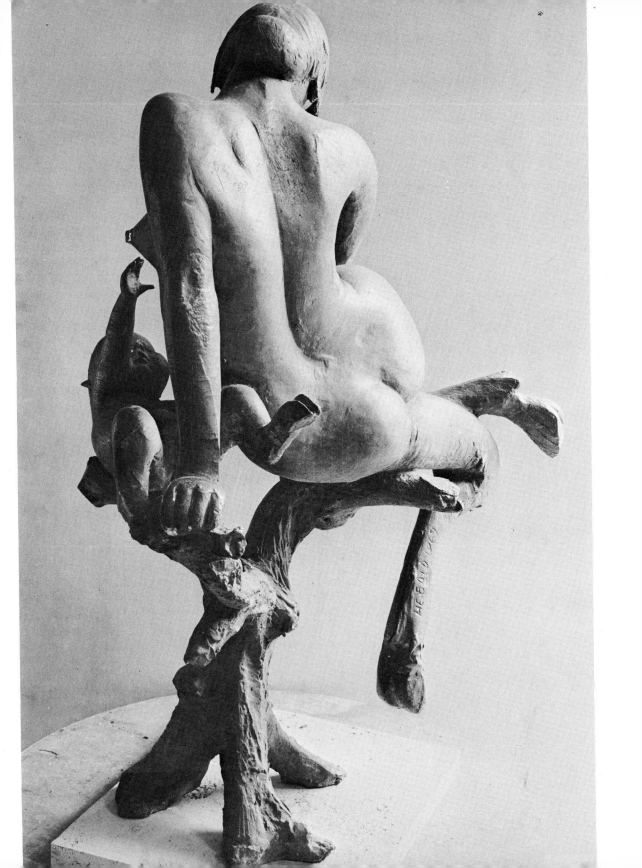

6

All sculpture is metamorphosis in one way or another: flesh into bronze, bronze into flesh, with the intermediary service of wax, clay, or plaster. Art is a form of transubstantiation, and nowhere is this clearer than in sculpture.

Hebald has always practiced portraiture, from the time the little boy on Fifth Avenue took the likeness of the bus, from the time the soldier in the South earned his weekends home by sketching his comrades. In Rome he has regularly turned his hand to portraits in bronze, and he thoroughly enjoys the work. "It's a change from sculpture," he has noted sardonically. But his heads in bronze—and too rarely in terra cotta—are sculpture by any definition. Hebald himself knows the distinction. He admires Epstein's portrait heads: "They are great works of art. He portrayed a generation." In contrast, "Jo Davidson's portraits look good in photographs, but not in themselves. They are not really sculpture."

Hebald's are.

In most of his sculpture, Hebald builds and cuts away in plaster, a material he is most fond of: "It can do anything." A wax is made from the plaster and the bronze from the wax, with the sculptor in total control over every step of the complex process, changing, adjusting, burnishing, finishing. For portraits, he works, usually, in clay or Plasticine. He loves terra cotta, but "It is not very popular because people want permanence," a preference Hebald, typically, smiles about, since terra cotta, on the historical record, is much more permanent than bronze.

An early and very sensitive portrait done in Rome was that of the poet Archibald MacLeish, when both he and Hebald were at the American Academy in 1958. The poet was about to end his presidency of the National

Academy of Arts and Letters, and it was customary for retiring presidents to present their portraits. MacLeish asked Hebald to do one of him, and a cast of the likeness went to the Sterling Memorial Library at Yale.

There exist a number of photographs of the poet in flesh and bone beside the poet in bronze. The comparison is highly revealing of what Hebald finds so attractive in portraiture. The likeness, of course, is exact. But in a curious way the bronze looks more like the poet than the poet does. The reason is clear enough. The camera catches an instant; if the instant happens to be felicitous, the photograph can be a marvel unobtainable by the other visual arts. But the essence of a person, especially of a poet, is not often revealed in a single instant. It comes out slowly, over many meetings, many things said, thoughts expressed, rethought, rephrased, exchanges made, relationships defined, aspects and angles noted and related.

One source of Hebald's strengths for many years has been his easy association with people who are not sculptors and painters, and especially with

ARCHIBALD MAC LEISH. Life-size; 1958.

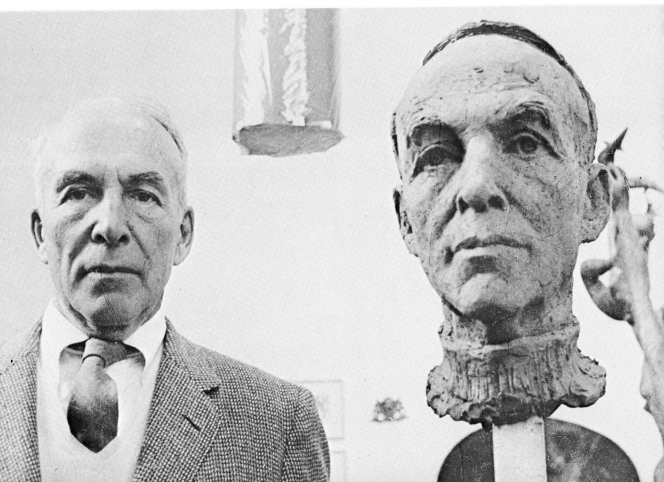

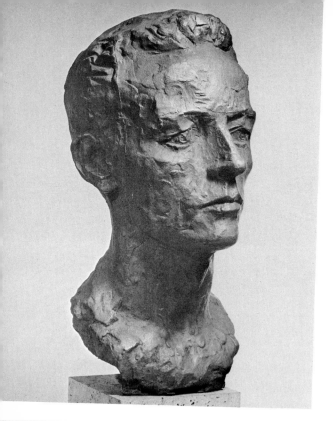

LEE NORDNESS. Life-size; 1965.

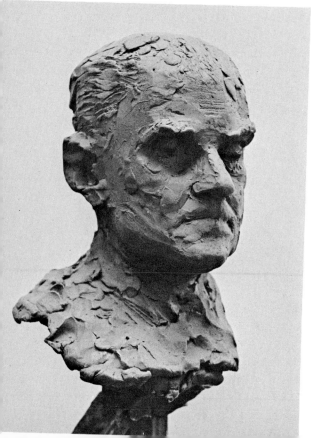

MAUD ELLMANN. Life-size; 1962.

ALBERTO MORAVIA. Life-size; clay; 1965.

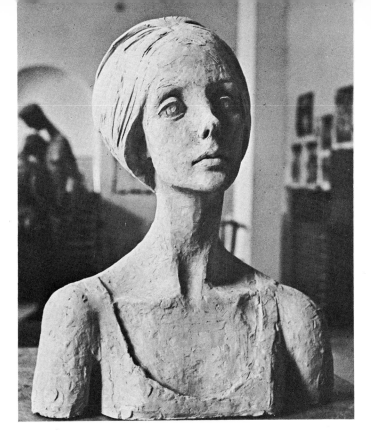

FREDA HYMAN. Life-size; terra cotta; 1967.

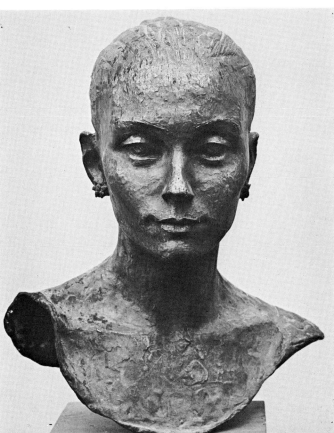

SIGNORA BETETA. Life-size; 1956.

poets and novelists. He got along well with MacLeish from the first. The poet wrote him a limerick in praise of sculpture, to wit:

> Said his wife to the sculptor, Praxiteles,
> "I know what you think when you whittle 'ese
> Flints and 'ese stones:
> You would whittle my bones
> To make Venus, complete with her tittlese."

The verse, to be sure, is more of a poet's rising to the challenge of the Greek name than it is immortal poetry. But this kind of easy give and take with literary men has seemed natural and important to Hebald. He left high school because it seemed irrelevant to his real education, but his education in literature and music has continued ever since. There is music in the air both at home and in the studio, and Hebald has said, "My head buzzes with music as I work." Most of the buzzing is provided by Brahms, Debussy, Stravinsky, Bartók, Schubert, Beethoven, and Franz Lehár.

In poetry, Hebald can—and will, with very little provocation—recite long passages from Chaucer and Shakespeare. It is entirely likely, in fact, that the sonnets will provide the source for the next substantial body of related works, as Joyce's *Ulysses* did a few years ago. He discovered Gibbon while serving in the army: "His prose knocked me for a loop, it was so beautiful. It cinched my interest in Rome." The historian remains a "constant companion," as does the penetrating Italian traveler Augustus J. C. Hare, whose complete works and walks are a cornerstone of the Hebald's Roman library. But Shakespeare abides, for Hebald, alone and above all: "I feel he couldn't have been merely human. He had to be divinely inspired. He was too good to be just a person like the rest of us. I don't feel quite that way about any painter or sculptor . . . even Bernini."

The portrait of MacLeish seems to be hearing the cadences of America and of freedom. The head of the Italian novelist Alberto Moravia gazes into a world of complex human emotions and ambitions, the Italian half-world of after the war that is lit by fitful gleams of lust or avarice amidst the encircling ennui. It is not that the head tells you anything about Moravia's novels; it is simply that if you know the novels, the head, a good likeness, is also wholly appropriate to their creator.

Maud Ellmann, the daughter of the literary critic, is the essence of little-girlhood, bright, alert, growing.

Freda Hyman, wife of the critic, Sidney Hyman, shows an extraordinary sensitivity in the eyes, the nostrils, even in the long, graceful neck.

There is an expanding gallery of his own generation that has come from Hebald's hands to say about the mid-century something equivalent to what Epstein said of the early years of the century. Like that master, Hebald uses the ''speaking likeness'' not as the aim of his sculptural portraits but only as the point of departure in pursuit of the spirit of the subject.

7

For the figurative sculptor, the important area of work has to be the figure. It has always been so with Hebald. For example, although he is totally competent in the field, he has done very few animal sculptures. "Murphy Alert" is the portrait of a cat the Hebalds owned—or which owned them. His brave bulls from time to time were really occasions for human achievement in rodeo or *corrida*. The fabulous beasts, including those of the zodiac, are really expressions of humanity rather than of animality. Two fine examples adorn the gateposts of the late C. V. Starr's country home at Brewster, New York.

The sphinx, on one side, with her big bosom, squatting haunches, and impassive face, is the ultimate view of the pussycat girl, an eternal personality type. On the other side, the centaur, clutching his club, his hand spread on what would be his hip if that part of him weren't horse, his baffled yet determined face, his aging strength—all these add up to a vision of man, not of animals from the nursery. But then, of course, so did the myths that gave us the sphinx and the centaur.

Beyond those gates so guarded is one of the finest collections of Hebald's work. Although he did not play the game himself, Mr. Starr maintained a small golf course for the pleasure of his guests. Several of Hebald's life-size works are encountered as one goes around the course, and in our society it is hard to think of a more advantageous setting. On a large outcropping of rock is "Handstand," a marvelously balanced male figure full of the knotted muscles of total tension in holding a difficult position.

To one side of a fairway stands the lush nude "Five Foot Two," hand holding her hair in a pose similar to that of "Homage to the Baroque." On

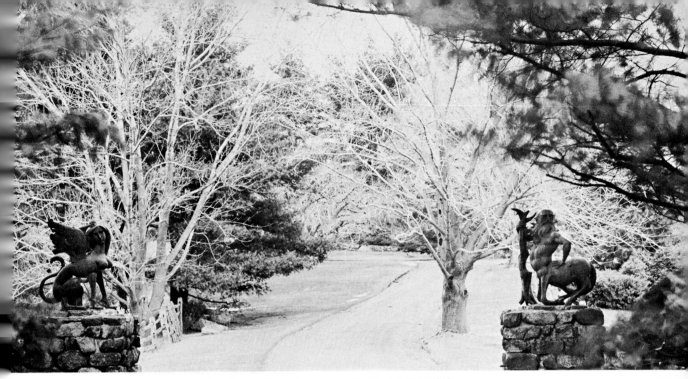

GATEPOSTS. SPHINX, 35⅜" high; CENTAUR, 37" high; 1962.

LITTLE SPHINX. 25" high; 1962.

LITTLE CENTAUR. 24" high; 1962.

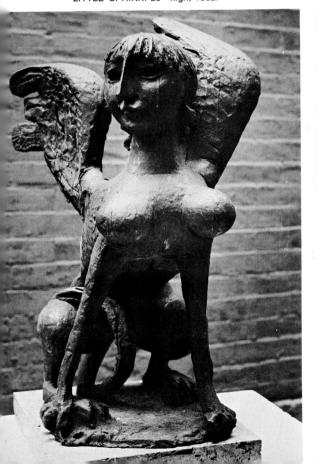

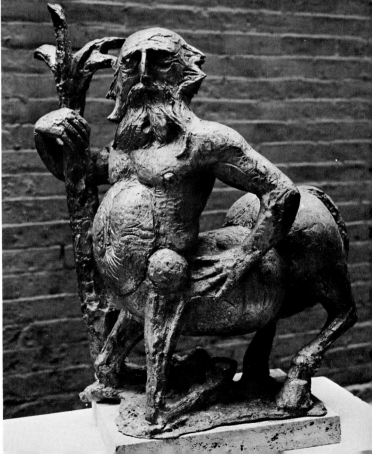

the edge of a sand trap is seated the opulent figure of the young Molly from Joyce's *Ulysses.* Magnificently situated under the long branch of a tree at the first fork in the entrance drive is the embracing pair of "Lovers" ("Amanti"), in a mood of repose and quiet, the girl's head on the man's shoulder, his bent over hers in protective love, their hands joined between them.

The idea of lovers beneath a tree is as old as man—or at least as old as man according to the Authorized Version—and Hebald has explored the theme in a sequence of works that show clearly how he changes, expands, and perfects an idea through a series of variations and sizes.

The twenty-two-inch early version of "Under the Apple Tree" is curvilinear in concept. The main sculptural motif is set by the serpent, rising up

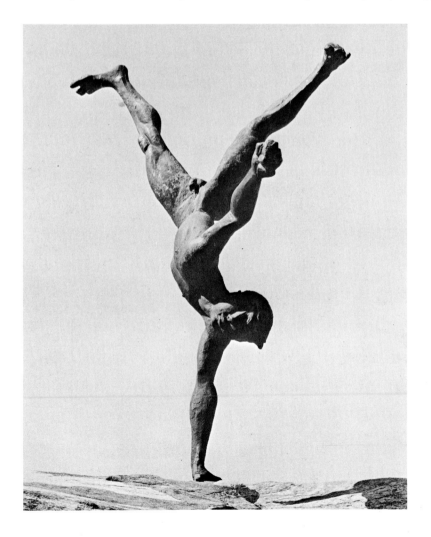

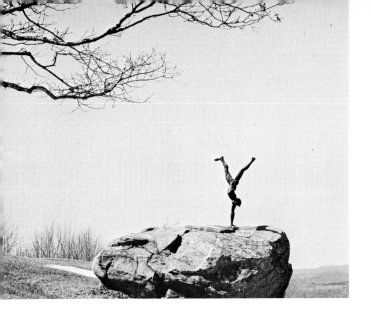

Opposite and above: HANDSTAND. 55½'' high; 1963.

Below and right: FIVE FOOT TWO. 62'' high; 1963.

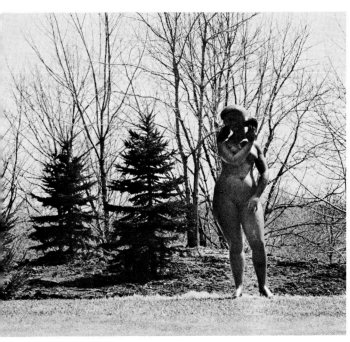

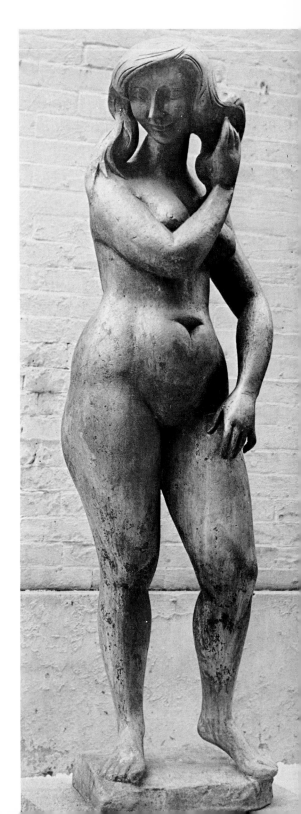

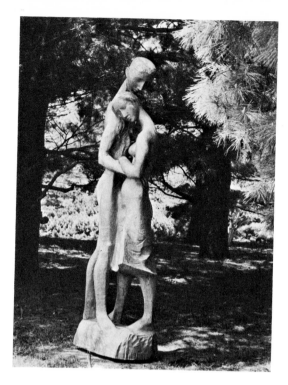

AMANTI. 76" high; 1963. Opposite: Detail.

from the ground in curves that are followed by tree branches and the woman's arm. Against these curves are the straight lines of the man's arms and legs and of the tree trunk.

The five-foot version is a complete change in concept. The lines and curves have been replaced by spherical surfaces. The mood has changed from the imminence of danger or temptation to fulfillment. The serpent is gone. The figures are more amply draped and their draperies lift in a breeze. The tree overhead is like a swelling cloud, and the child stands upon it as a good omen. The couple are more united; they close in to each other as the setting closes around them. At their feet the three-footed stand of the smaller version has become the roots of the tree, another integrating change, and the trunk of the tree has developed its own swelling protuberances.

The strong-blowing wind of "The Tempest" has also had a thorough explanation by Hebald. He likes the kind of movement that wind can give to figures and draperies caught in it. Although he is capable of observing, "Sometimes I get tired of all the movement going on in my sculpture," his tiredness doesn't last long.

In 1950 Hebald carved in teak the couple of "Storm." He carves as fluently as he models, and he enjoys direct carving as a change from model-

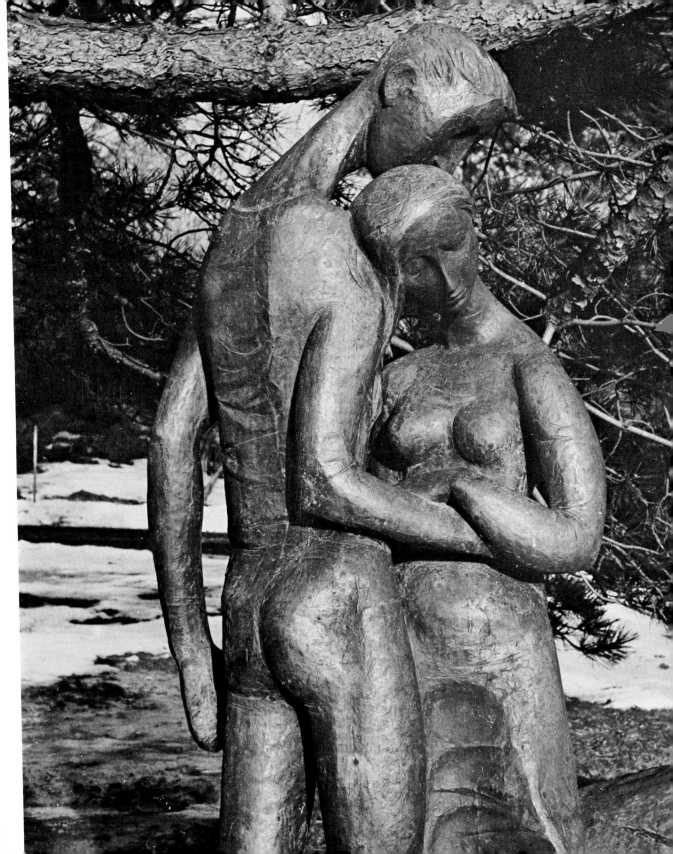

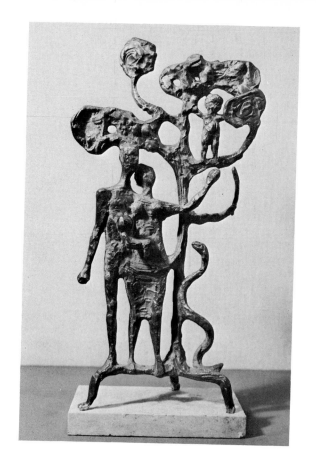

APPLE TREE STUDY II. 22″ high; 1963.

ing. Most of his work, in any case, involves some carving in the plaster. But carving wood, he has said, "lends itself more to fantasy. It is a liberation of what is inside the wood, as opposed to bronze, where you start with ideas, make small models, and enlarge them. The experience of carving is more exciting than the experience of modeling."

Carving, of course, also lends itself to surface dazzle, the reflections of a thousand little planes, the sense of quivering life. In one way or another that sense enhances most of Hebald's work in any medium. It is certainly present in "Storm," dancing all over the surfaces like the lights on a choppy sea. The major balances in the work are like expertly set sails in such a sea: the skirt below, the cloak above; the man's left arm bent above the woman's head, her arm bent up to his face; his right arm curving down to her waist to connect, visually, the cloak and the skirt.

Four bronzes, done in 1963 and 1964, elaborate the theme. The bronze "Storm," like the wood, employs the cloak held overhead to play against

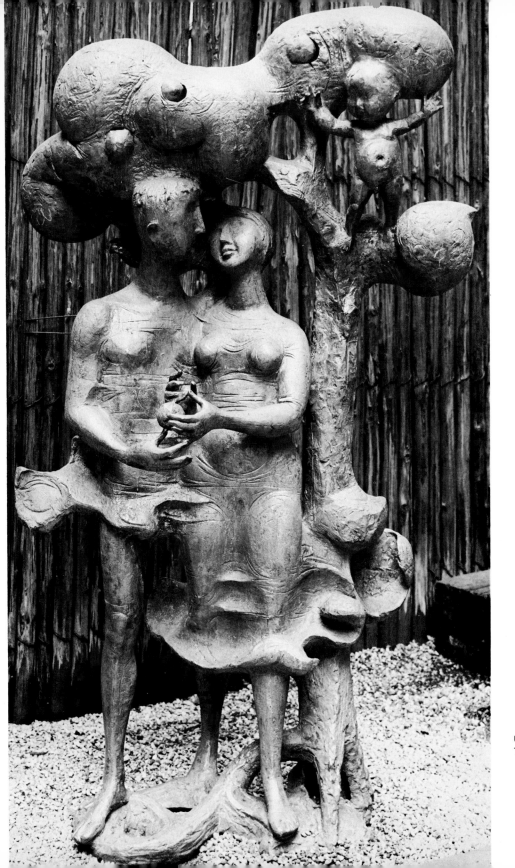

UNDER THE APPLE
TREE. 59″ high; 1963.

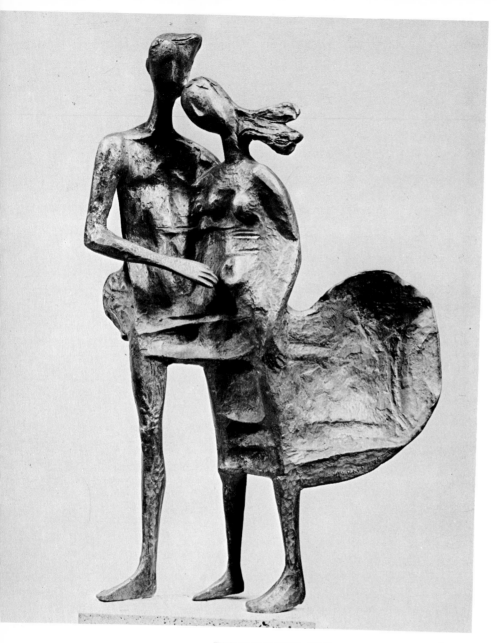

TWO IN THE WIND. 17½" high; 1963.

the billowing skirt. The wind produces a ribbed effect in the couple's clothing so that they seem bound together, an ingenious idea that Hebald uses also in the other bronzes.

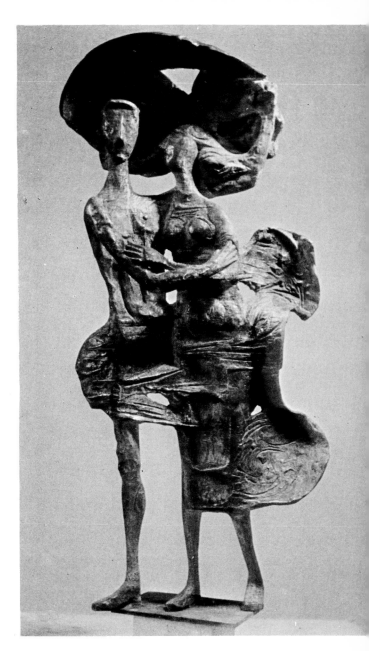

WINDBLOWN. 17½″ high; 1961.

STORM I. 22″ high; 1961.

"Two in the Wind" concentrates all the scattered drapery of "Storm" into one great billow of skirt. The wind has risen: the dress presses against the body of the girl and the "bonds" that tie the couple together are more pro-

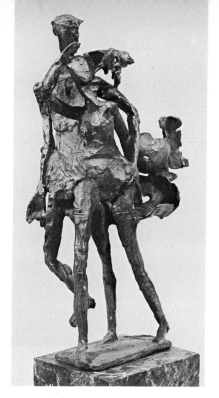

STORM II. 10½" high; 1962.

Opposite: MR. AND MRS. H. 34" high; 1962.

nounced. "Windblown" makes those bonds or ribs a major element of the sculpture. The lines go back and forth almost like those on a loom, and although the drapery is one solid sheet, it is hollowed out into two curved areas, up and down, bridged by a plane.

A particularly lovely embodiment of the theme is "Mr. and Mrs. H." The "H" stands not for Hebald but for Heymann: Margo Hebald, after early schooling in Rome, graduated from Cornell University, where she studied architecture. She married her instructor, the English architect Sigfried Heymann. The couple live and practice in California.

Like their predecessors, Mr. and Mrs. H. are caught in the wind. He turns to her. Her flattened-out skirt is balanced by the wall-like fabric that cups his hip. The ribs of fabric join them together, and their hands and forearms are tenderly intertwined.

Hebald has never hesitated to use the people around him as models, and the people most often around him have been his wife and daughter. "Cecille at Recorder," a musical moment in 1952, is notable for the utter intensity of concentration. The theme is elaborated in "Recorder Player" of the same year, with a pleasant profusion of the parts of the chair set against the player. More elegantly, "Gloves" shows Cecille off for a visit. The same year, 1958, she is the seated "Cecille." Both small works derive their life

100

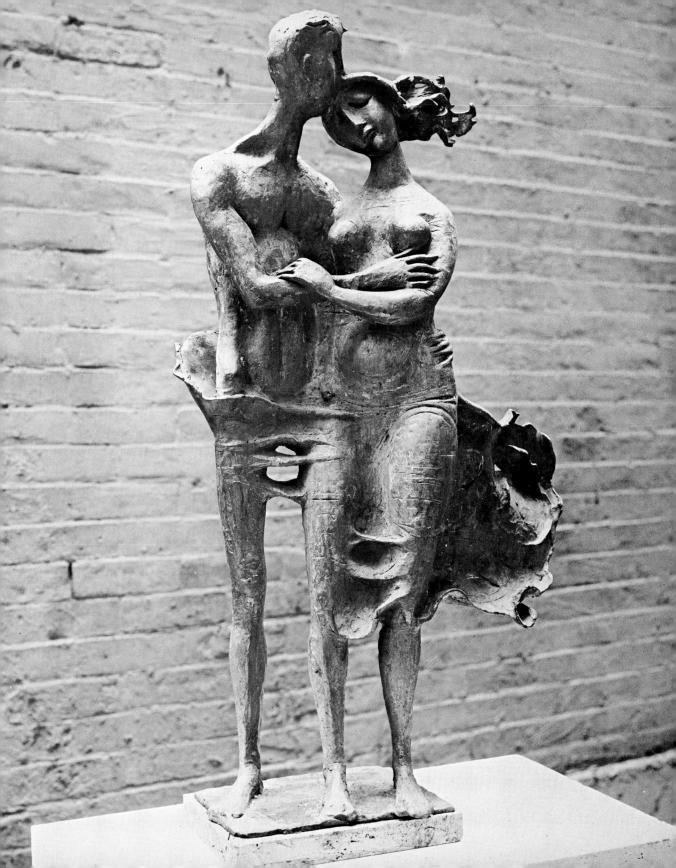

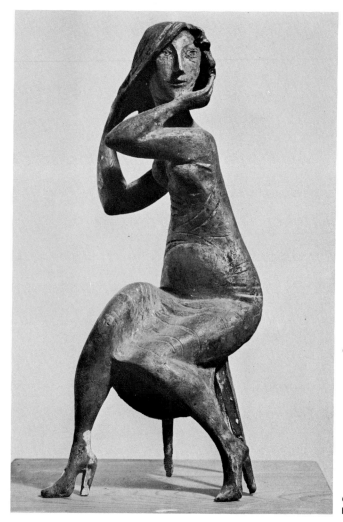

CECILLE. 12½" high; 1958.

Opposite: MARGO IN VENICE. 20" high; 1956.

from the fluid arrangement of masses. There is an unseen spiral within them both which animates the limbs and the torso and leaves its only overt marks in the incised lines on the dresses.

Margo appears in 1956 as a beanpole adolescent growing into feminine grace. "Margo Reading," of 1955, has the distinction of being the first bronze Hebald did in Rome. The experience was a revelation of technical ease and competence all around him, no longer a rarity to be desperately sought but an available skill to be used freely. The piece itself has some-

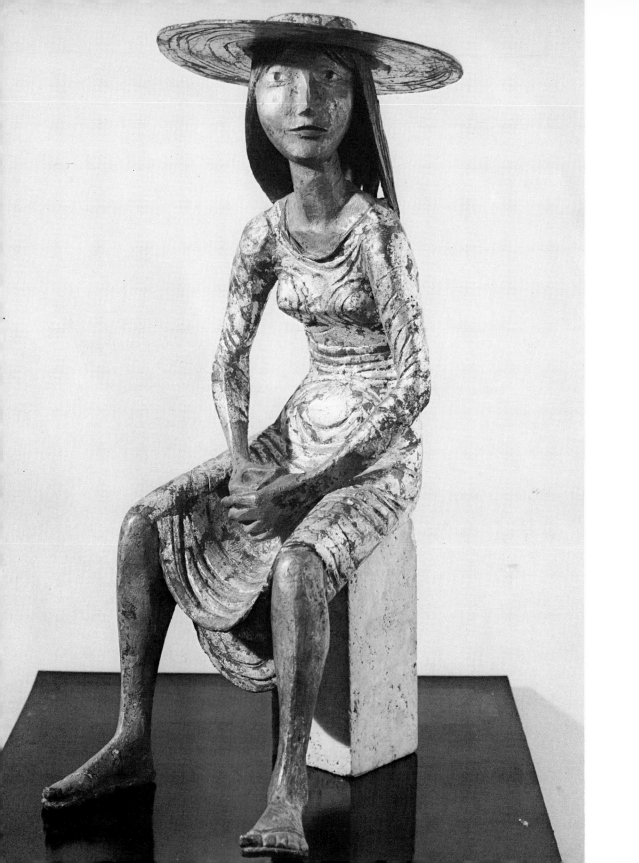

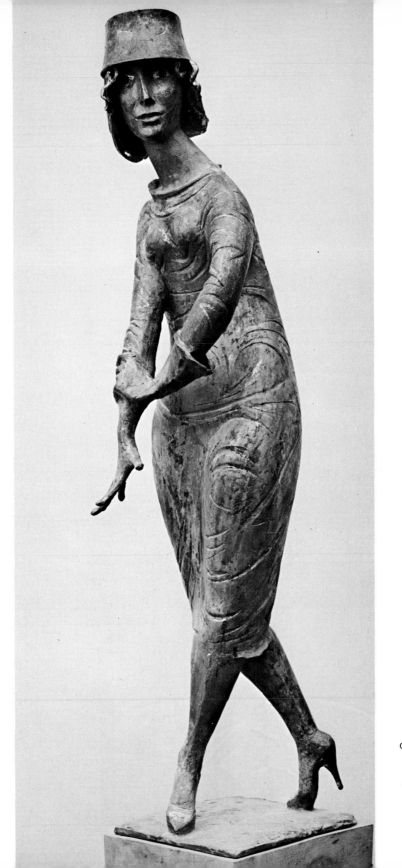

GLOVES. 37″ high; 1958.

BIKINI. 33½'' high; bronze
and silver leaf; 1957–1958.

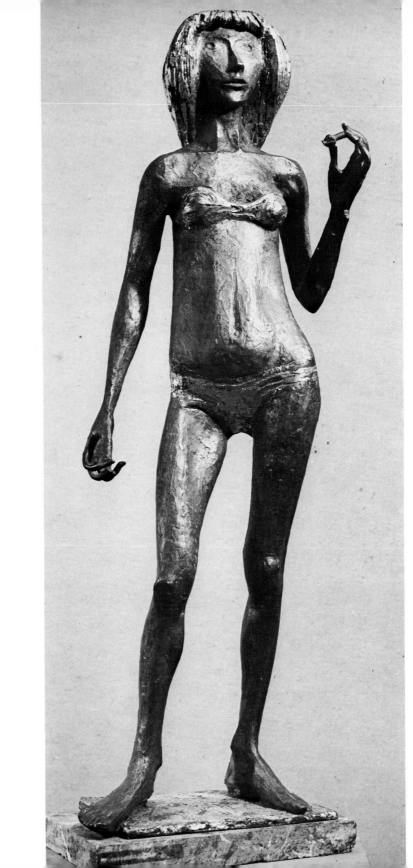

BIRD SONG. 18″ high; 1961.

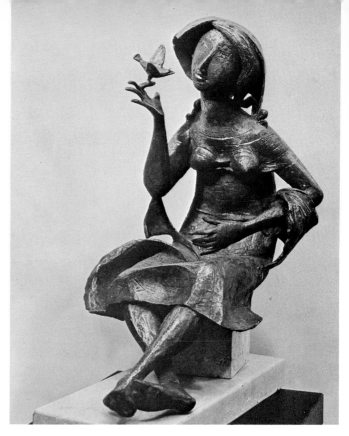

Below: GIRL DANCING ("TWISTER," POR-
TRAIT OF DIANE HENRY). 26″ high; 1965.

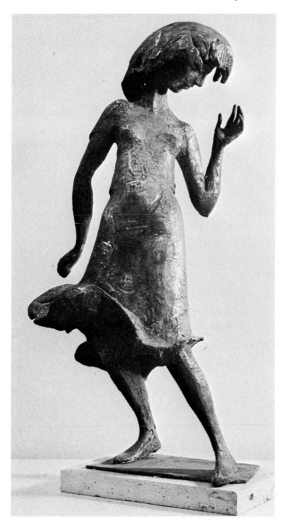

Right: SEATED DRAPED WOMAN. 18″ high; 1961.

Opposite: SPANISH DANCER. 24″ high; 1963.

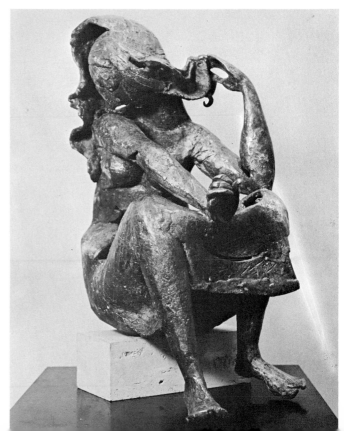

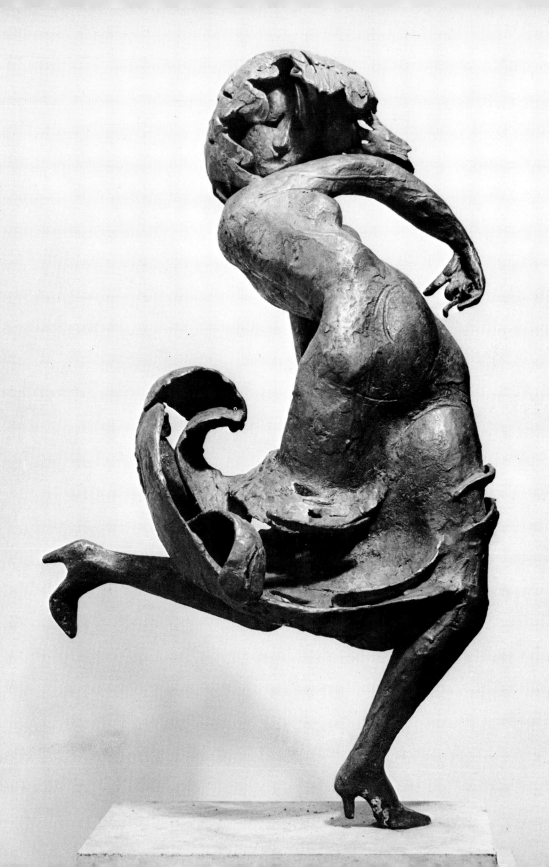

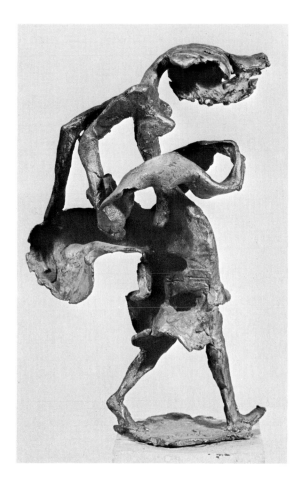

SMALL EXORCISM. 12″ high;
1964.

Opposite: POSSESSED. 28½″
high; 1965.

thing of the solemn good feeling that marks the Etruscan tomb effigies the Hebalds are so fond of.

Like all classical sculptors, Hebald has found that the female form, draped and undraped—and in that rare combination of the two that Hebald has mastered—can express a wide range of emotions. "Girl of Trastevere," 1956, is a marvelous and funny playing of forms one against another, almost like the work of a great billiard player. The hair, which in life is lacquered, seems more substantial than the breasts. From neck to heel the body is much like a Baroque candlestick. And all of this is balanced against the exaggerated delicacy with which the girl holds the apple, the ancient symbol of temptation.

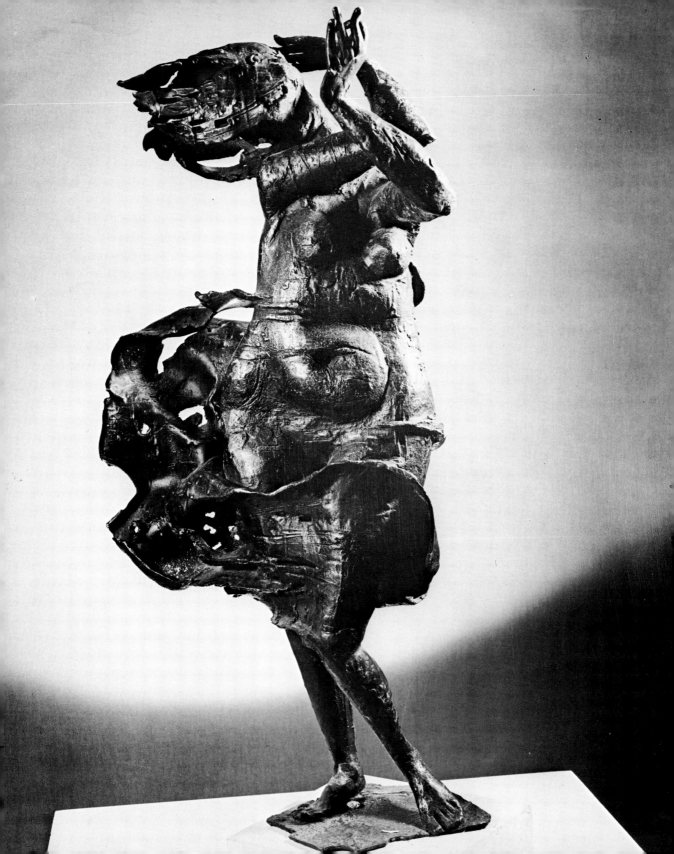

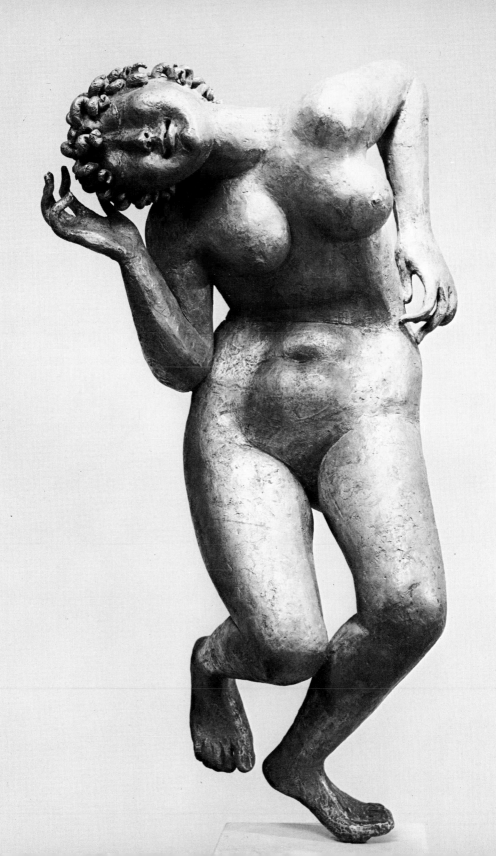

"Bikini," 1957–1958, has exactly the right kind of body for that kind of bathing suit, lean and spare, angular—even bony—topped by the rather stupid gaze. "Spanish Dancer" is quite different. It's all movement, and the movements are those of the dance: bold arcs of arm and leg, of skirt, and of hair flung around the head like a drape.

Two versions of "Woman with Drapery," 1960, contrast two modes of the flow, the movement, the motion that constitute one of Hebald's great strengths as a sculptor. Both works are high reliefs rather than fully rounded figures. The one with the head turned to the figure's left is full of open spaces: six, to be exact, one on either side of the waist, one on either side of the neck, and one between each hand and the hair it holds. The drapery and the hair flow in graceful curves all over the figure. The arms and legs flow in a similar way. There is a real merging together of flesh and fabric in the matter of motion, despite the defining spaces. In the piece in which the girl's head is turned to her right, on the contrary, there is only one tiny piercing of actual space—the three openings between the fingers of her left hand. The rest is solid bronze, without break. Yet the body is quite distinguishable beneath the flux and flow of the elaborately and gracefully disposed drapery.

The second piece is in the Whitney Museum, as is an earlier Hebald, the teakwood "Woman with Birds," of 1947. "Woman with Birds" shows perhaps the fullest development of Hebald as a purely American sculptor. The modeling and the carving are beautiful and the conception is thoroughly sculptural, but the possibilities realized are few compared to the artistic world Hebald opened up for himself just a few years later in Rome.

In Hebald's sculpture there is what might be called a "dark side." His work, by and large, is cheerful, often amusing, always engaging. It is pleasant to be with and fascinating to study closely because so much is going on. But in a few pieces he has focused on the mysterious, the tragic, or the occult aspects of the ancient myths and legends that have provided him with much of his inspiration. Like Italy, Hebald is a sunny artist. But he has also worked by moonlight, with clouds obscuring most of that.

"Bacchante," in both the 1964 and 1965 versions, is not simply a classical worshiper of the god. She is quite drunk in her dance. The earlier version, with hair in short curls, has a lump of a body, expressing her intoxication, and the hands seem to grapple, uncertainly, with the problems of who she is, and what's happening. In the later version (not illustrated) she

BACCHANTE II. 29¼″ high; 1964.

WOMAN INTO CHAIR (VERSION I). 20″ high; 1963.

WOMAN INTO CHAIR (VERSION II). 25″ high; 1963.

seems about to collapse altogether. The piece is admirably balanced on the toes of one foot. The left hand holding the grapes to the hip recalls, interestingly, the same gesture in the "Bacchus" of Michelangelo's youth.

The ancients held that bacchantes were possessed by the god. Later problems of demoniac possession are treated in two works, both unique bronzes made directly from wax: "Exorcism," 1964, and "Possessed," 1965. In each, the girl's face is lost in the sweep of her disordered hair. Again, the body seems filled with a great lump in "Possessed," while in "Exorcism" —the departing of the evil spirit from the possessed person—there is a great peeling off of lumpy substance, a kind of heavy ectoplasm.

The most tragic of these dark, or moonlit, works is another unique bronze, "Electra," shown at the end of the catastrophic events that engulfed her. Her mother murdered her father on his return from the Trojan war for the sake of her lover. Electra incited her brother, Orestes, to kill their mother and then saw him driven mad by the avenging Furies. At that point, Hebald depicts the young girl made into a crone by the whirlpool of tragedy. The back is particularly expressive of the sheer depletion suffered by the tragic heroine.

"Salty Stare," originally titled "Lot's Wife," of 1959, can hardly be classed with these dark subjects. The piece was obviously taken off the streets of Trastevere, seen in a backward turning pose that reminded the sculptor of the lady in Genesis who looked back and was turned into a pillar of salt. But the small work relates, in subject, to a major piece of 1964, "Lot and His Daughters," another unique bronze.

Hebald has always done figure groups. One of the loveliest is the "Three Graces," a classical subject Hebald has executed in several versions. In all of them the Graces are endowed with the appealing awkwardness of real, live young girls, blended with the sweet charms of the mythic figures themselves. There is endlessly graceful play of arms and legs and the volumes of buttocks and breasts all linked together by hair flowing in the wind.

Things are different with "Lot and His Daughters," a group in which all motion seems stopped, life itself suspended even in the act of drunken carousal. The story is familiar: The cities of the plain, Sodom and Gomorrah, were destroyed by fire from heaven for their evil ways. Lot, having bargained in vain with God to spare the cities, escaped with his family. After the loss of his wife, he and his two daughters arrived at a place of safety. It seemed to

114

the girls that all humanity had been destroyed. Therefore, to conceive heirs, to carry on the race, they purposely got their father drunk and then "went in to him," in their crude shelter.

The subject has another meaning for Hebald. Since living in Italy, the Hebalds have become well informed on art, antiquities, and furniture. To some degree they follow those markets, with no particular impulse to buy or sell but out of the wish to know what's going on. From this activity they have acquired a varied collection of ancient marbles, vases, prints and drawings, sculpture, and paintings. The most commanding and the most valuable work in the collection is a large, all but life-size painting by the North European Mannerist master Joachim Anthomsz Wtewael. The subject is "Lot and His Daughters."

Wtewael has lavished himself upon all the flesh, upon the murky landscape with the cities in flame in the distance, and upon the still-life subjects that naturally appear in a scene of general debauchery. The painting was in the Howard Collection, in Sussex, for generations and, in its north-south link and its sheer mastery, is one of the authentic landmarks of the history of Mannerist painting.

Hebald's approach to the subject is different in every way, even though he pays homage to Wtewael in the still-life arrangement placed on the head of the kneeling daughter. Typically, Hebald goes to the psychological heart of the story, which is, after all, a horror story rather than, as with the Mannerist, the occasion for beautiful painting. Again, there is a certain loss of identity. Lot's face is completely obscured by streaming hair and wine from the goblet he holds aloft. The kneeling daughter likewise has her eyes covered by hair, while the standing girl closes her eyes against what is taking place. The daughters have had to efface their father's consciousness of things in order to achieve their goal; in the process, inevitably, they are effacing their own as well.

The grace that springs so readily from Hebald's fingers is almost completely missing. The stiff figures seem awkward, half demented. The piece is a marvel of volume relationships. Elsewhere Hebald has had groups turning in upon themselves. Here the members are turning out, away from one another. The coming together is reluctant and generates its own opposite movement. The work is a masterpiece of formal and psychological values in total unity.

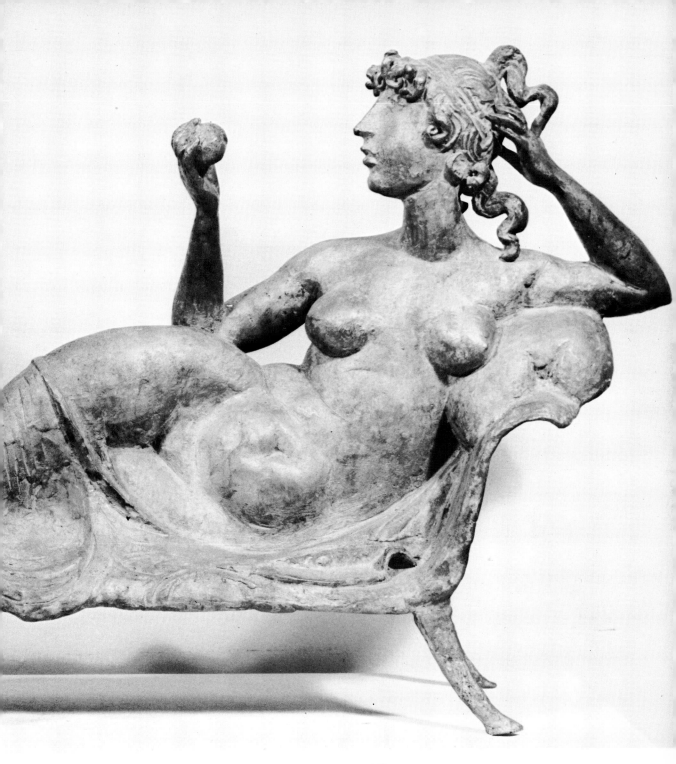

PAOLINA. 16½" high x 29"; 1962.

THREE GRACES II. 25″ high; 1959.

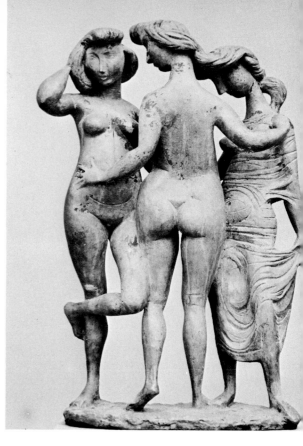

THREE GRACES STUDY; 10″ high; 1959.

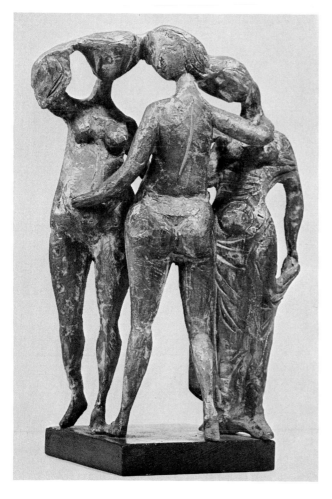

Opposite: THREE GRACES III. 4′ high; 1961.

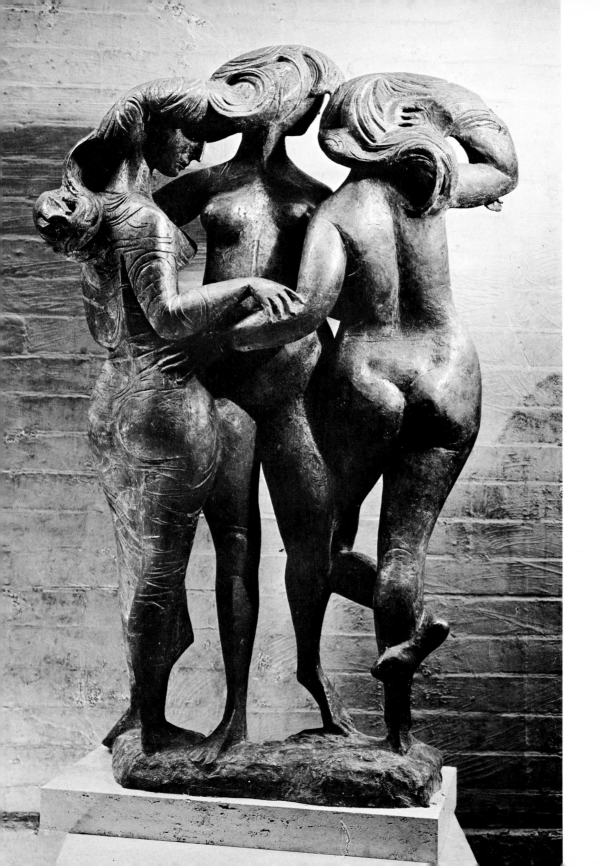

PROMETHEUS. 25″ high; 1962. *Opposite:* MATRIARCH. 48″ high; 1961.

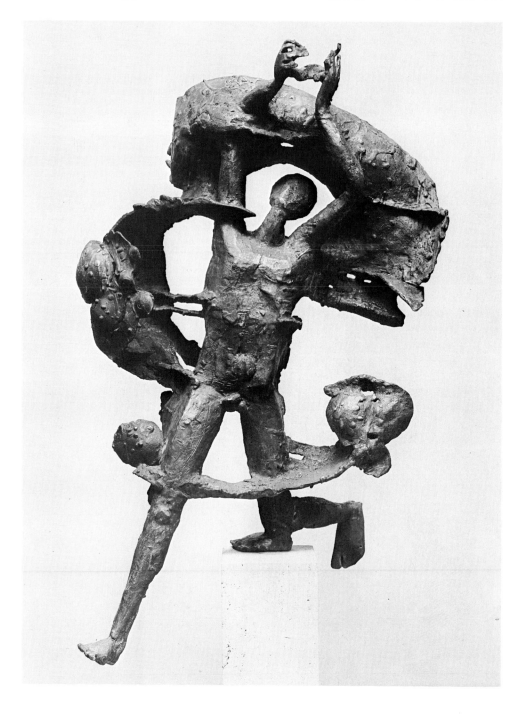

8

The most casual walk through any of the world's great art museums ought to be enough to demolish that contemporary notion that illustrative art, or literary art, or art that means anything at all is somehow wrong. From Giotto to Delacroix, illustrating is what the great painters were doing. In sculpture the run is even longer, extending from MacLeish's Praxiteles to Rodin, whose great lifework was the illustration of Dante. In view of such a history, it is absurd to state baldly that illustration has nothing to do with art. On the record, it has everything to do with it.

Hebald was never taken in by purist propaganda. As a child he automatically illustrated much of what he read: Dostoevski, Whitman, Melville, and Shakespeare, among others. Many of his figures are from Greek or Roman myths or from the Bible. But his greatest work in the illustration of literature is undoubtedly the group of figures he has made—and will doubtless add to from time to time—based on the characters and events of James Joyce's *Ulysses*.

It was hardly an original reaction for Hebald to come upon Joyce as upon a revelation. The English language was suddenly new again, as it must have been to Chaucer's audience. Words were banged together and created new meanings. Puns and wordplays went off like fireworks. Syntax created itself anew. Yet the verbal pyrotechnics were not there for themselves alone. They gave the faithful impression of the actual thoughts in a man's mind as they flowed along, interrupted, repeated, switched on or off by the most casual stimulus. Within that language, moreover, and within the travels of the Jewish advertising solicitor through the streets of Dublin, there were buried the structure, the events, and the characters of one of Western man's first great,

JAMES JOYCE MONUMENT STUDY. 17″ high; 1964.

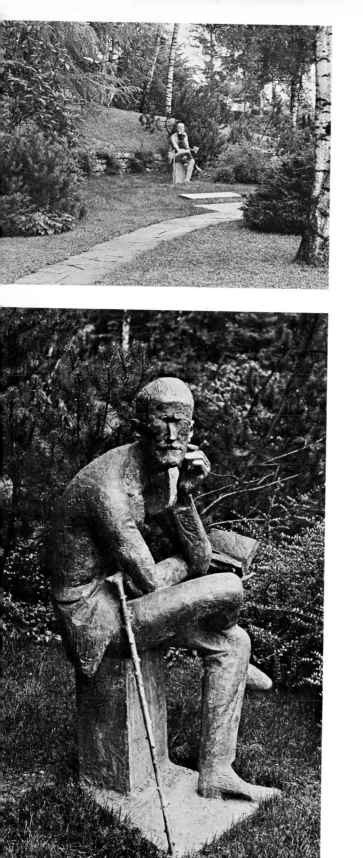

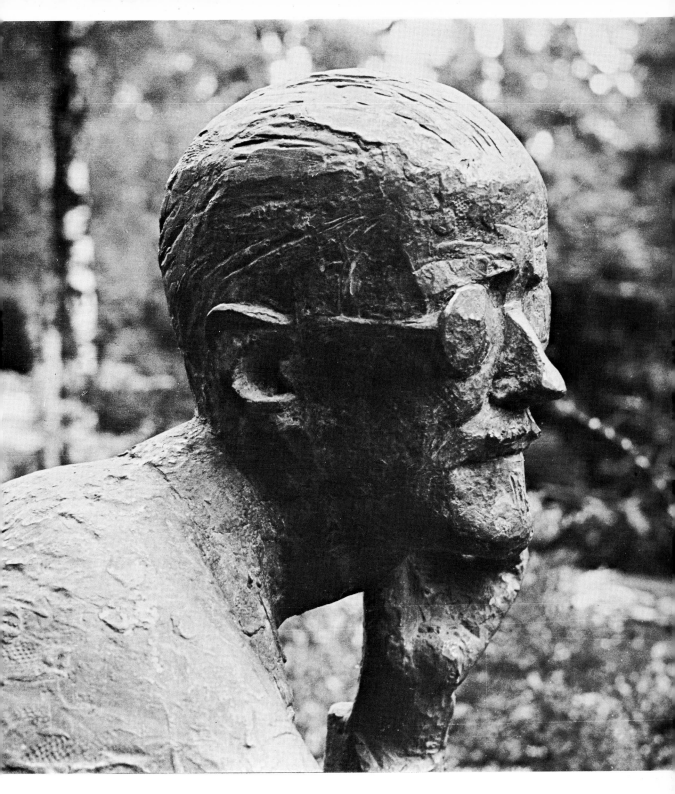

JAMES JOYCE MONUMENT. Life-size; 1966.

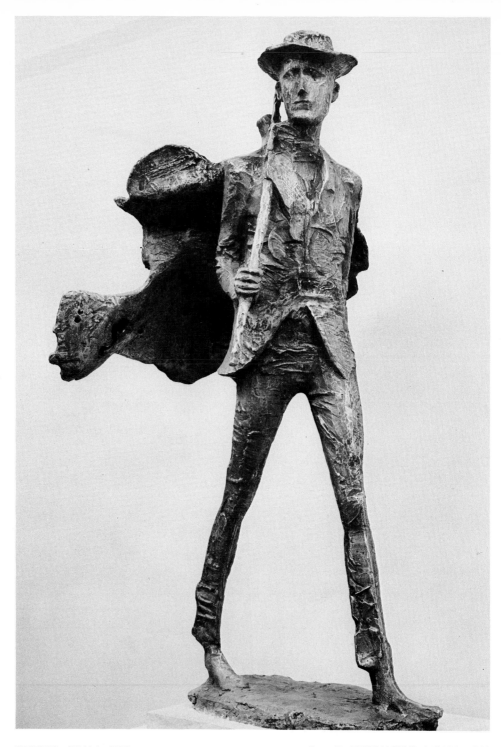

PROTEUS. 40″ high; 1966. *Opposite:* TELEMACHUS. 34″ high; 1966.

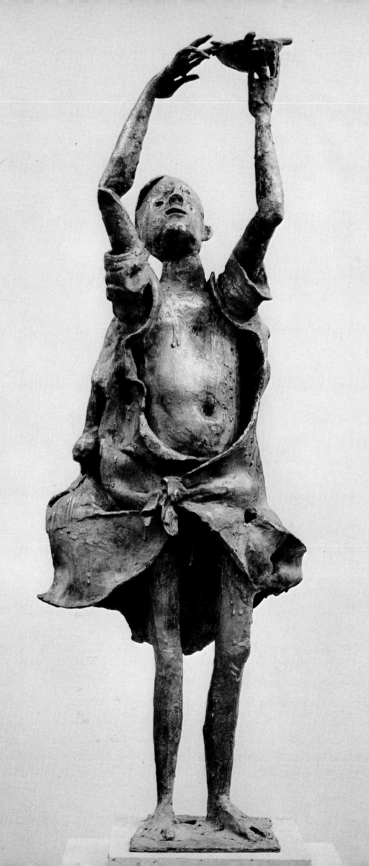

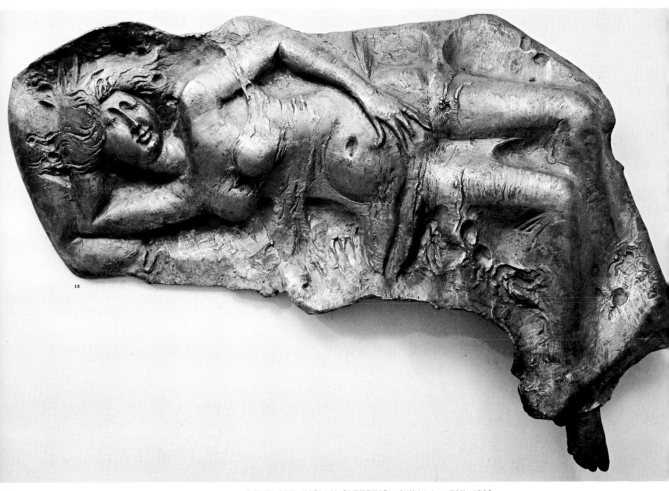

PENELOPE (MOLLY SLEEPING). 34″ high x 59″; 1966.

universal epic poems, the *Odyssey*. Joyce was rediscovering Homer's stories for his own century. But this is also what Hebald does with much of his effort—with Lot, with the zodiac, with Electra, Prometheus, and others. Like Joyce, he penetrated the past and revealed its arts to be entirely relevant to his own time. Granted this correspondence of purpose, it was almost inevitable that Hebald would eventually translate Joyce into sculpture.

The principal translated object is the writer himself. Hebald's monument of Joyce is the result of a double revelation, totally unexpected to either participant, Hebald and his dealer, Lee Nordness. Like Hebald, and like many others, Nordness, while attending the university in Sweden, had been pro-

foundly transformed by Joyce, so much so that some years later he made the single literary pilgrimage of his life—to visit the writer's grave in Zurich. He was shocked to find Joyce buried in the potter's field of the Zurich cemetery, the grave marked only by a bronze plate just big enough to contain the name.

In 1963 Nordness again visited the grave and was even more deeply shocked to learn that, in accordance with local custom, Joyce's remains were soon, after twenty-five years, to be cast into the lake to make room for another occupant in the potter's field. Nordness immediately began taking action, seeing the mayor and Joyce's son, George, and arranging to postpone the deposition and to procure a suitable burial place.

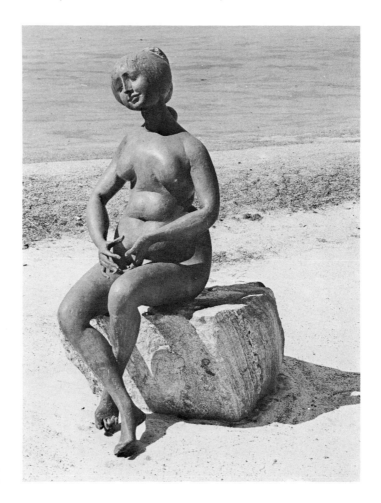

MOLLY SEATED.
48″ high; 1966.

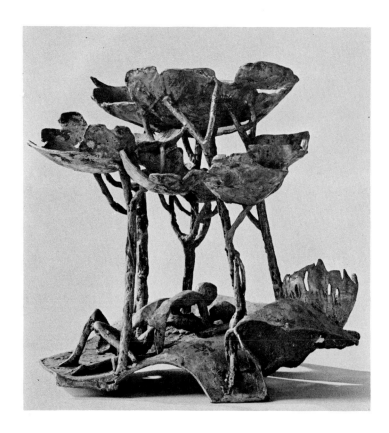

SEEDCAKE. 17½" high
x 17½" x 14"; 1967.

Opposite: NAUSICAA.
24" x 24" x 24"; 1966.

Nordness stopped in Rome to visit Hebald and to propose a monument to the writer. To their mutual astonishment, each discovered that the other was as grateful to Joyce and as intimately familiar with Joyce as he was himself. The life-size monument for the grave, commissioned by Nordness, became a joint gift to the memory of Joyce and to the course of modern literature. Nordness was also instrumental in moving Nora Joyce's body to lie again beside her husband. For both men, the life-size monument in Zurich is a payment on a debt both are glad to acknowledge.

The monument may well be the most completely successful memorial full-figure portrait in the mid-twentieth century. The touch for that kind of work has almost vanished from contemporary knowledge. Hebald has preserved it. The life-size figure, seated on a block, leans forward in meditation. The right elbow rests on the crossed leg, the hand holds an open book. The left hand, holding a cigar, touches the cheek. The thick, opaque glasses

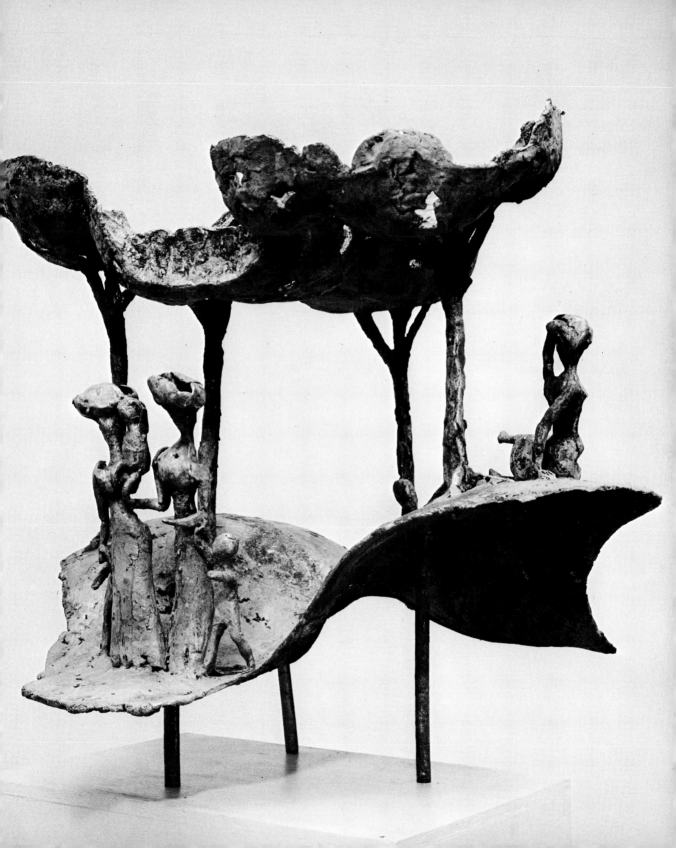

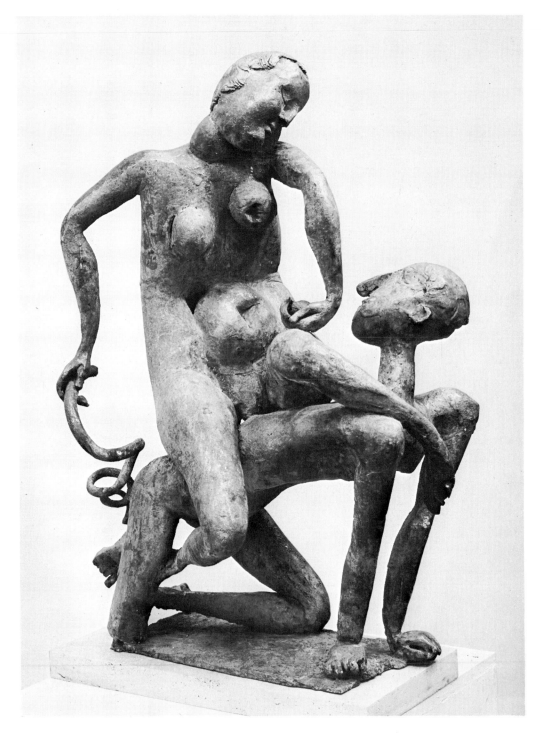

CIRCE. 30″ high; 1966.

Opposite: CYCLOPS. 28″ high; 1966.

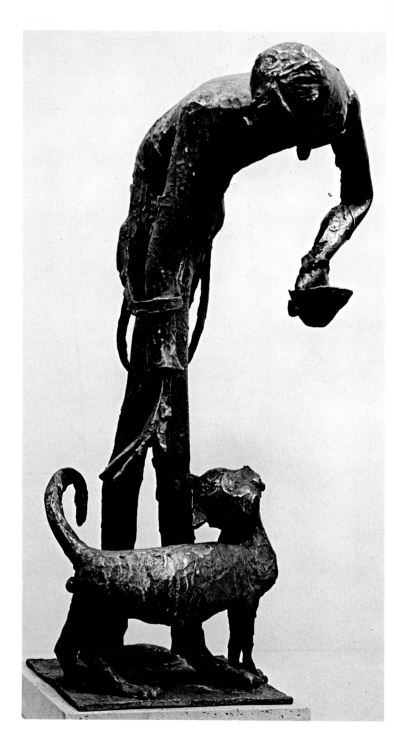

CALYPSO. 23¼'' high; 1966.

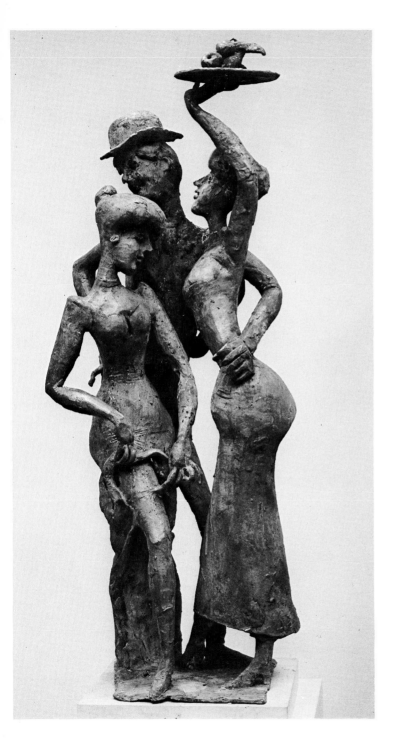

SIRENS. 30″ high; 1966.

WANDERING ROCKS. 21″ high x 31″; 1966.

reinforce the inward vision of the subject. An Irish walking stick rests on his leg. The likeness is good not only according to old photographs but according to a reading of the novels.

The memorial was an act of homage and gratitude. The figures from *Ulysses* continued the sculptor's debt to the writer.

We see the young Joyce as Proteus, striding across the city he loved and left, his cloak swelling out behind him as if it were a cloud full of the people he was to create. We see Molly-Penelope, seated, nude, rounded, vacuous, yet worthy of the salvation she received in the writing. Telemachus—played in the novel by Buck Mulligan—raises a libation to the sun. Bloom-Ulysses bends to pet Calypso—the family cat—and give her a saucer of milk. The almost liquefied wall of Hades is thickly peopled with the Dublin lowlife that

LESTRYGONIANS. 15" high x 23"; 1966.

Bloom and Stephen discovered. One of the rarest sculptural forms in the series is the view of Phoenix Park, with its little hills and bushes, its population of coupling couples, and its lush roof of tree branches.

The setting, the people, the events are translated convincingly into bronze. This is beyond illustration in the conventional sense. Joyce brought Homer to a different kind of life, incidentally going out of his way to use the Roman rather than the Greek form to further underline the process of reinterpretation. Similarly, Hebald has given a new and different kind of life to Joyce's world. Michelangelo did not "invent" Adam, but the figure on the Sistine ceiling is a noble interpretation that tells us much about the idea of Adam that we do not read in scripture. Hebald has done just that with Leopold Bloom and his townsmen.

HADES. 21″ high x 31″; 1966.

9

Hebald does not, as a matter of fact, think very highly of invention. There is more, much more, to art than that, he has said.

"The real emotions, the ones that count, are emotions in relation to other human beings. These can be translated into sculpture. People have been doing it for centuries.

"I will not succumb to the blackmail that the artist has to interpret and only interpret the present age. The basic ideas explored by the Greeks have been restated and reinterpreted many, many times by many, many artists. Each one finds something there that we did not know was there before.

"There is no real danger of confusing yourself with earlier artists. No one could possibly mistake the cathedral on Riverside Drive for a thirteenth-century Gothic church. No one of any experience would for a moment think a Canova sculpture was Greek or Roman.

"Many of the basic truths in sculpture are humanistic truths. We cannot avoid the fact that the vital thing is human life on this earth."

Hebald, of course, has never remotely tried to avoid it. That's what his art is about.

He quotes Kafka: "The hardest thing is to avoid the influence of your contemporaries." Hebald has succeeded in that difficult task, yet his work is unmistakably of his time.

With extraordinary self-knowledge, he noted recently, "One of my limitations is that I'm too unlimited."

It was one of Joyce's, too, in a different way. Both artists have overcome the handicap.

SHAKESPEARE'S MIRROR. 30" x 20"; 1968.

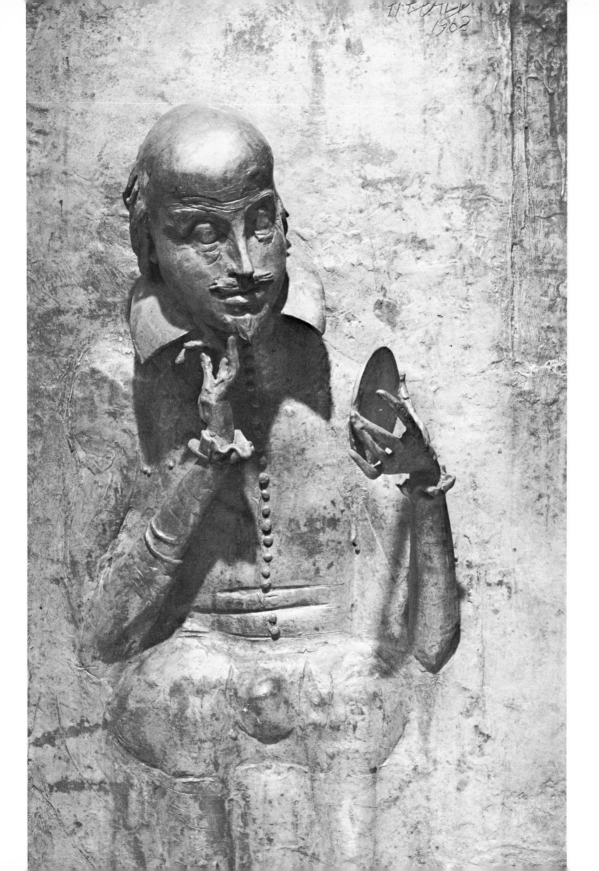

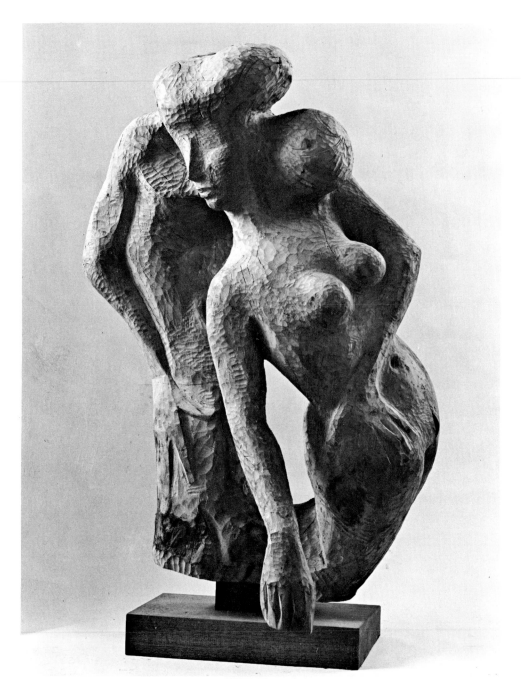

DAPHNE. 41″ high; wood; 1967. *Opposite:* MELANCHOLY BABY. 24″ high; 1969.

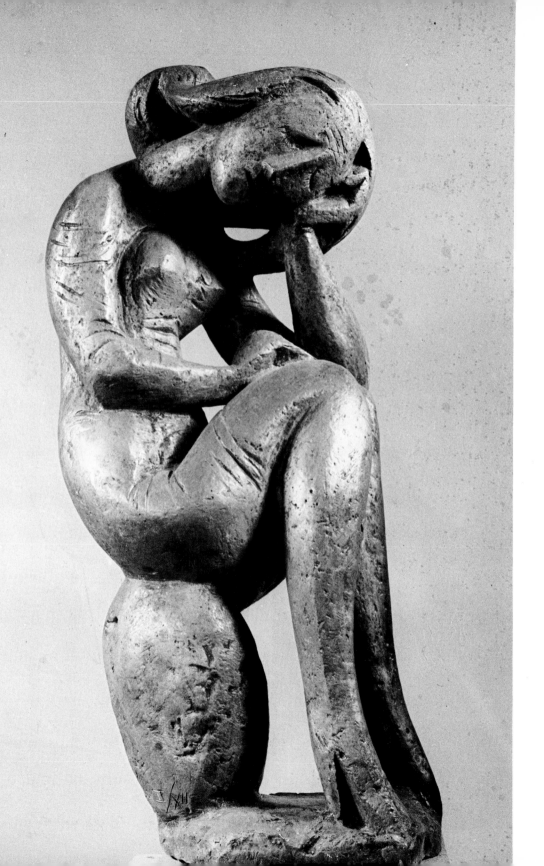

EMERGING HEAD. 29″ wide; 1970.

BEACH AT BRACCIANO. 27″ wide; 1970.

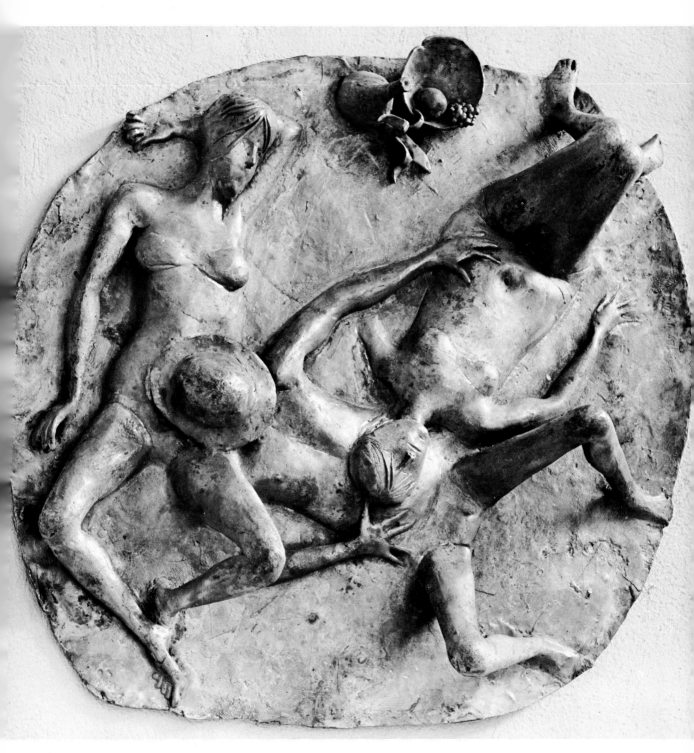

SIESTA. 30'' wide; 1970.

PASSING CROWD. 20″ high; separables; 1970.

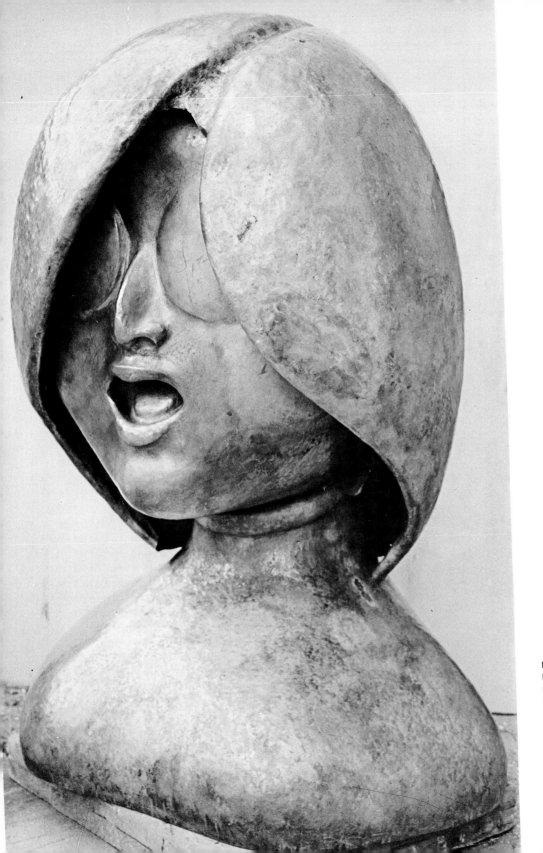

MONUMENT TO THE
FALLEN AT VASSAR.
56″ high; hammered
brass; 1970.

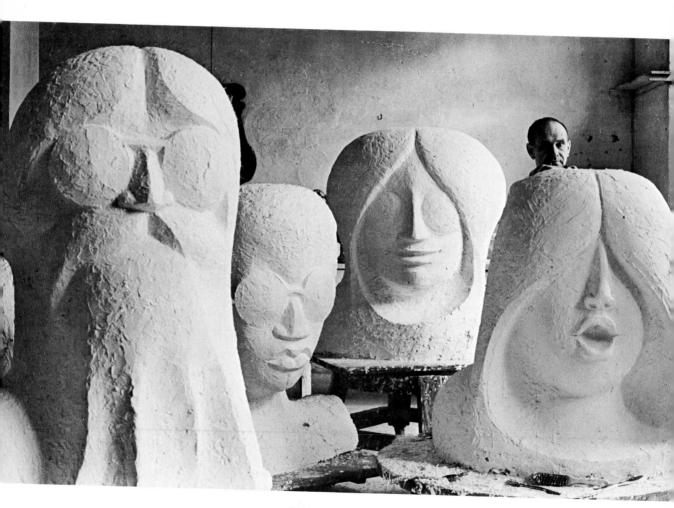

GIANT HEADS. In progress.

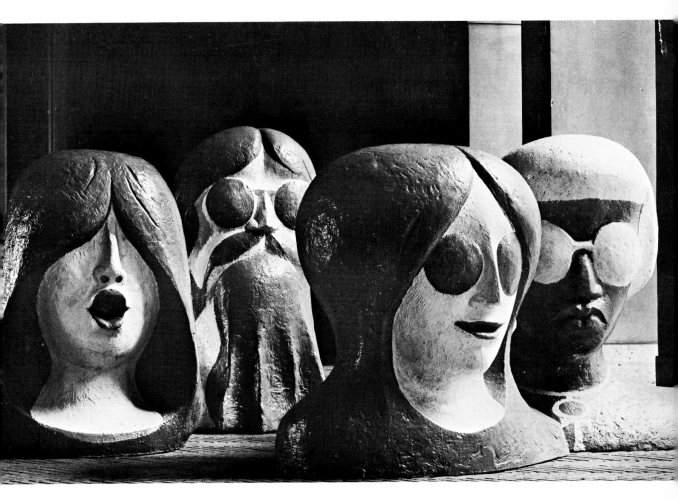

GIANT HEADS. 3' high; plaster; 1970.

DOCUMENTATION

ALBERTO MORAVIA: ed. unique; collection—Milton Hebald (Rome, Italy); photograph—Milton Hebald. 1965.

ALONG THE TIBER: ed. unique; collection—Milton Hebald; photograph—Oliver Baker. 1957–1958.

AMANTI: ed. 3; collections—Johnson Foundation, gift of Irene Purcell Johnson (Racine, Wis.), the late C. V. Starr and companies associated with him, Avnet Collection (New York); photograph—Johnson Foundation. 1963.

APPLE TREE STUDY II: ed. 6; collections—Mrs. Harry Ashmun (New York), Leonard Schanfield (Chicago), W. R. Hawn (Dallas); photograph—Geoffrey Clements. 1963.

AQUARIUS (from ZODIAC SCREEN): ed. unique; collection—Pan American World Airways, J. F. Kennedy International Airport (New York); photograph—Walter Rosenblum. 1960.

ARCHIBALD MAC LEISH: ed. 2; collections—Academy of Arts and Letters (New York), Sterling Memorial Library (New Haven); photograph—Milton Hebald. 1958.

ARIES (from ZODIAC SCREEN): ed. unique; collection—Pan American World Airways, J. F. Kennedy International Airport; photograph—Walter Rosenblum. 1960.

BACCHANTE II: (VERSION II); ed. unique; collection—Lee Nordness Galleries (New York); photograph—Geoffrey Clements. 1964.

BATHERS: ed. 10; collections—Mrs. H. F. Johnson (Racine, Wis.), Walter B. Ford II (Detroit), Silvia Glick (New York), Robert Merrill (New York); photograph—Geoffrey Clements. 1963.

BATHTUB BOX: ed. 6; collection—Charles Newman (New York); photograph—Geoffrey Clements. 1963.

BEACH AT BRACCIANO: ed. 6; collection—Lee Nordness Galleries; photograph—Oscar Savio. 1970.

BIKINI: ed. 6; collections—Pennsylvania Academy of Fine Arts (Philadelphia), A. Kahan (New York); photograph—Oliver Baker, 1957–1958.

151

BIRD SONG: ed. unique; collection—Alvin Greenstein (New York); photograph—Soichi Sunami. 1961.

BOATING ON TOMS RIVER: ed. unique; collection—Toms River (N.J.) Post Office; photograph—Soichi Sunami. 1941.

BURLESQUE: ed. 12; collections—Mr. and Mrs. Richard Tucker (Great Neck, N.Y.), Dr. Bud Schwartz (Baltimore); photograph—R. Baldi. 1967.

BURNING BUSH: ed. unique; collection—Lee Nordness Galleries; photograph—Walter Rosenblum. 1969.

CALYPSO: ed. unique; collection—Lee Nordness Galleries; photograph—Geoffrey Clements. 1966.

CANCAN: ed. 3; collection—the late C. V. Starr and companies associated with him; photograph—Walter Rosenblum, 1969.

CECILLE: ed. 6; collections—Armand G. Erpf (New York), Carol Solway (Toronto), Gerald Gidwitz (Chicago), Ann Sang (New York); photograph—Oliver Baker. 1958.

CHILDREN AT PLAY: ed. unlimited; collections—Henry L. Bromberg (Dallas), Mrs. Harry Ashmun (New York), Samuel L. Rosenfeld (Oceanside, N.Y.), Joe Baumgold (New York), James Bonsall (Montclair, N.J.), Richard Qwiskin (New York), Crosby and George Bonsall (Newark, N.J.); photograph—Geoffrey Clements. 1961.

CHILDREN'S GAMES: ed. unique; collection—Lee Nordness Galleries; photograph—de Casseres. 1949.

CIRCE: ed. unique; collection—Lee Nordness Galleries; photograph—Geoffrey Clements. 1966.

CIRCUS MAXIMUS: ed. 6; collection—Philadelphia Museum of Art; photograph—Milton Hebald. 1950.

A CLODIAN: ed. 6; collections—Seneshal Ostrow (Los Angeles), Dr. and Mrs. Seymour Dubroff (Washington, D.C.), Mrs. John Campbell (Cincinnati), the late C. V. Starr and companies associated with him (Brewster, N.Y.); photograph—Geoffrey Clements. 1963.

CONVERSATION: ed. 6; collection—Lee Nordness Galleries; photograph—R. Baldi. 1967.

CORNUCOPIA: ed. unique; collection—Tennessee Fine Arts Center (Nashville); photograph—Geoffrey Clements. 1964.

CRUCIFIXION STUDY: ed. unique; collection—Lee Nordness Galleries; photograph—Milton Hebald. 1960–1961.

CYCLOPS: ed. 6; collection—Lee Nordness Galleries; photograph—Geoffrey Clements. 1966.

DAILY NEWS: ed. 6; collection—Lee Nordness Galleries; photograph—R. Baldi. 1967.

DAPHNE: ed. unique; collection—Milton Hebald; photograph—Milton Hebald. 1967.

DRAPED FIGURE: ed. 6; collections—the late C. V. Starr and companies associated with him, Mr. and Mrs. John F. Lott (Lubbock, Texas), Whitney Museum of American Art, given in memory of Samuel L. Stedman by his wife (New York); photograph—Geoffrey Clements. 1960.

ELEMENTS IN A LIFE (dedicated to Stephen Crane): ed. unique; collection—Lee Nordness Galleries; photograph—Soichi Sunami. 1940.

ELEMENTS IN A LIFE STUDY: ed. unique; collection—Lee Nordness Galleries; photograph—Soichi Sunami. 1940.

EMERGING HEAD: ed. 6; collection—Milton Hebald; photograph—Oscar Savio. 1970.

ETRUSCAN WARRIORS: ed. unique; collection—Dr. and Mrs. G. Feinberg (Huntington Station, N.Y.); photograph—Geoffrey Clements. 1959.

FAUN MOTHER: ed. 6; collection—Lee Nordness Galleries; photograph—Oscar Savio. 1969.

FIVE FOOT TWO: ed. 6; collections—the late C. V. Starr and companies associated with him, Avnet Collection; photograph—Walter Rosenblum. 1963.

500 METERS: ed. 6; collections—the late C. V. Starr and companies associated with him, Mrs. Sidney Goodman (Minneapolis), Mr. and Mrs. Chapman Riley (Worcester, Mass.), R. J. Rudick (New York), Paul Weissman (New York); photograph—Geoffrey Clements. 1962.

5000 METERS: ed. 12; collections—Arkansas Art Center (Little Rock), Sobel Stanton (San Francisco), Gerta Green (Armonk, N.Y.), Milton Goldberg (Glencoe, Ill.), Mr. and Mrs. Nathan Finklestein (New York), Jack Seichek (Philadelphia), Ralph Ogden (Mountainville, N.Y.), Mrs. Bella Linden (New York); photograph—Geoffrey Clements. 1961.

FREDA HYMAN: (terra-cotta version); ed. unique; collection—Sidney Hyman (Chicago); photograph—Milton Hebald. 1967.

FRUG GROUPS: ed. 12; collection—Mr. and Mrs. Sol Jay Lasser (New York); photograph—Geoffrey Clements. 1967.

152

GATEPOSTS: ed. unique; collection—the late C. V. Starr and companies associated with him; photograph—Walter Rosenblum. 1962.

GEMINI (from ZODIAC SCREEN): ed. unique; collection—Pan American World Airways, J. F. Kennedy International Airport; photograph—Walter Rosenblum. 1960.

GIANT HEADS: ed. unique; collection—Lee Nordness Galleries; photograph—R. Baldi. 1970.

GIRL DANCING ("TWISTER," PORTRAIT OF DIANE HENRY): ed. 6; collection—Joseph Winston (Brooklyn, N.Y.); photograph—Geoffrey Clements. 1965.

GIRL OF TRASTEVERE: ed. 6; collection—Gardner Cowles (New York), Edith Halpert (New York); photograph—Geoffrey Clements. 1956.

GLOVES: ed. 6; collections—Don B. Press (Beverly Hills), Tennessee Fine Arts Center; photograph—Oliver Baker. 1958.

GONGS: ed. unlimited; collections—Mr. and Mrs. John Kluge (New York), Louis C. Crawford (Chicago), Mrs. Ansley Sawyer (Buffalo), Mr. and Mrs. Stephen Stone (Newton Centre, Mass.), Mr. Ed Weiss (Chicago), Mr. and Mrs. Robert Gallop (New York), Mrs. Seymour Oppenheimer (New York), Mrs. Orhan Sadik-Khan (Boston), Mr. and Mrs. Hal Goodman (New York), Barnet Hodes (Chicago), Louis M. Rusitzky (Boston), Mrs. Edmond J. Thayer (Scottsdale, Ariz.), Ella Winters (London, England), Eleanor Hempstead (New York), Hilda Solomon (Chicago), Nancy Simon (New York), Crosby and George Bonsall (Newark, N.J.), Mr. and Mrs. David Steine (Nashville, Tenn.), Mr. Bert D'Acosta (Tripoli, Libya), Helen Ford (New York), Mr. and Mrs. John Levy (Metuchen, N.J.), Mr. and Mrs. Gerald Andrus (New Orleans), Mr. and Mrs. Ronnie Karr (White Plains, N.Y.), Mrs Edward Kafritz (Washington, D.C.), Mr. and Mrs. Henry Marcus (Chicago), Mary Nimkoff (New York), Paul Weissman; Mel May (New York), Ludwig Nugass (New York), Charles Newman (New York); photograph—Walter Rosenblum. 1950.

GREAT FORTUNE: ed. 6; collections—Charles A. Wustum Museum of Fine Arts, gift of Irene Purcell Johnson (Racine, Wis.), Avnet Collection; photograph—Oscar Savio. 1967.

HADES: ed. unique; collection—Lee Nordness Galleries; photograph—Geoffrey Clements. 1966.

HANDSTAND: ed. unique; collection—the late C. V. Starr and companies associated with him; photograph—Walter Rosenblum. 1963.

HANUKKAH MENORAH MODEL: ed. 6; collections —Norman Bernstein (Washington, D.C.), Sidney Mickelson (Washington, D.C.), Leo Bernstein (New York); photograph—Milton Hebald. 1964.

HARVEST: ed. 6; collections—Arkansas Arts Center, gift of anonymous donor (Little Rock), Mr. and Mrs. Gardner Cowles (Miami Beach, Fla.), Mr. and Mrs. Saul Rosen (Paterson, N.J.), Norman Bernstein (Washington, D.C.), University of Arizona (Tucson); photograph—Oliver Baker. 1957.

HIM TO THE GREAT SPIRIT: ed. unique; collection—Sidney Mickelson (Washington, D.C.); photograph—Oliver Baker. 1959.

HOMAGE TO THE BAROQUE: ed. 3; collections— Dr. Helen Boigon (New York), Armand G. Erpf (New York), Mr. and Mrs. H. H. Boscowitz (New York); photograph—Oliver Baker. 1958.

JAMES JOYCE MONUMENT: ed. 6; collections— Fluntern Freidhof (Zurich, Switzerland), Avnet Collection; photographs—Andreas Wolfensberger. 1966.

JAMES JOYCE MONUMENT STUDY: ed. 12; collections—Mrs. Wirt Morton (New York), Mr. and Mrs. Robert Eisenstein (Nashville, Tenn.), Dr. Roger Burgos (Arlington Heights, Ill.), George Herrick (New York), Dr. Richard A. Schwalb (Dover, N.J.), Mr. and Mrs. John Coleman (Chicago), Walter Reade, Jr. (Oakhurst, N.J.), Mr. and Mrs. George Joyce (Munich, Germany), Mr. and Mrs. P. R. Herzig (New York), Charles E. Kellogg (Hyattsville, Md.), Mr. and Mrs. Jerome Pastor (Los Angeles); photograph—Geoffrey Clements. 1964.

JITTERBUGS: ed. unlimited; collections—George Herrick, Mrs. Carl Leff (New York), Dr. Leon Braverman (Coatsville, Pa.), Mrs. Madeline Chapman (New York), Mr. and Mrs. Carl Henry (New York), Mr. and Mrs. D. Israeler (Trenton, N.J.); photograph—Geoffrey Clements. 1957.

JOY OF LIFE: ed. unique; collection—Mr. and Mrs. Ralph Pomerance (Cos Cob, Conn.); photograph—Walter Rosenblum. 1963.

JUNGLE GYM: ed. unique; collection—Burton D. Hoffman (New York); photograph—Walter Rosenblum. 1946.

LEE NORDNESS: ed. unique; collection—Lee Nordness (New York); photograph—O. E. Nelson. 1965.

LEO (from ZODIAC SCREEN): ed. unique; collection—Pan American World Airways, J. F. Kennedy International Airport; photograph—Walter Rosenblum. 1960.

LESTRYGONIANS: ed. 6; collection—Lee Nordness Galleries; photograph—Geoffrey Clements. 1966.

LITTLE CENTAUR: ed. unique; collection—Lee Nordness Galleries; photograph—Geoffrey Clements. 1962.

LITTLE SPHINX: ed. unique; collection—Lee Nordness Galleries; photograph—Geoffrey Clements. 1962.

MARGO IN VENICE: ed. 9; collections—Margaret Phillips (New York), Gardner Cowles (New York), Walter Beardsley (Elkhart, Ind.), Mr. and Mrs. Daniel Eisenberg (Brooklyn, N.Y.), Warren Ramsey (Oklahoma City), David Selznick Estate (Hollywood, Calif.), Bert Smokler (Detroit); photograph—Oliver Baker. 1956.

MATRIARCH: ed. 6; collection—Mr. and Mrs. Myron Minskoff (New York); photograph—Geoffrey Clements. 1961.

MAUD ELLMANN: ed. unique; collection—Mr. and Mrs. Richard Ellmann (Cambridge, Mass.); photograph—Milton Hebald. 1962.

MELANCHOLY BABY: ed. 12; collection—Wilber Pritchard (New York); photograph—Thomas Feist. 1969.

MERMAIDS AND TRITON: ed. 6; collection—Lee Nordness Galleries; photograph—Soichi Sunami. 1961.

MR. and MRS. H.: ed. unique; collection—Mrs. Herman Gross (Great Neck, N.Y.); photograph—Geoffrey Clements. 1962.

MOLLY SEATED: ed. 3; collections—the late C. V. Starr and companies associated with him, Armand G. Erpf (Arkville, N.Y.); photograph—Walter Rosenblum. 1966.

MONUMENT TO THE FALLEN AT VASSAR: ed. unique; collection—Milton Hebald; photograph—Milton Hebald. 1970.

MUSIC: ed. unique; collection—Walter Prokosch (Cos Cob, Conn.); photograph—Milton Hebald. 1958.

NAUSICAÄ: ed. unique; collection—Lee Nordness Galleries; photograph—Geoffrey Clements. 1966.

NEPTUNE FOUNTAIN: ed. unique; collection—A. W. Geller (New York); photograph—Walter Rosenblum. 1961.

NEPTUNE STUDY: ed. 4; collections—Webb and Knapp, Inc. (New York), Mr. and Mrs. Harold C. Schonberg (New York), Mr. and Mrs. A. A. Rosen (New York); photograph—Geoffrey Clements. 1961.

NOAH'S ARK: ed. 6; collection—Prairie School, gift of Irene Purcell Johnson (Racine, Wis.); photograph—Soichi Sunami. 1961.

PAOLINA: ed. 6; collections—Senator William Benton (New York), the late C. V. Starr and companies associated with him, Mr. and Mrs. John Coleman (Chicago), Eugene L. Gross (Riverdale, N.Y.), Mr. and Mrs. Walter Sharp (Nashville, Tenn.); photograph—Geoffrey Clements. 1962.

PASSING CROWD: ed. 6; collection—Milton Hebald; photograph—Oscar Savio. 1970.

PASTORAL FOUNTAIN: ed. unique; collection—Lee Nordness Galleries; photograph—Geoffrey Clements. 1960.

PENELOPE (MOLLY SLEEPING): ed. 6; collection—Lee Nordness Galleries; photograph—Geoffrey Clements. 1966.

PICADOR: ed. 12; collections—Jerry Stern (New York), S. Schwartz (Chicago), Mr. and Mrs. A. A. Rosen, Mr. and Mrs. William Weil (New York), Barbara Quackerbus (Rome, Italy), Mrs. Alan Boegehold (Providence, R.I.), Edith Halpert, (New York); photograph—Peter A. Juley. 1957.

PLANTER: ed. unique; collection—Lee Nordness Galleries; photograph—Geoffrey Clements. 1948.

POSSESSED: ed. unique; collection—Ed Dickson (Houston); photograph—Nickerson. 1965.

PRESSED FLOWER: ed. 6; collections—Arnold Weissberger (New York), Jack Lawrence (New York); photograph—Oliver Baker. 1958.

PROMETHEUS: ed. unique; collection—Mr. and Mrs. Albert Small (Washington, D.C.); photograph—Geoffrey Clements. 1962.

THE PROMISE: ed. 6; collection—Mrs. Mary G. Roebling (Trenton, N.J.); photograph—Geoffrey Clements. 1957.

PROTEUS: ed. 10; collections—Lee Nordness Galleries, Virginia Museum of Fine Arts (Richmond); photograph—Geoffrey Clements. 1966.

RAPE OF THE SABINES: ed. 6; collections—Sanford M. Granowitz (New York), Mr. and Mrs.

Theodore Schwartz (Detroit); photograph—Milton Hebald. 1956.

RATTO DI SABINE: ed. 15; collections—Walter Cerf (Brooklyn, N.Y.), Donald Rush (Minneapolis), Mr. and Mrs. Douglas Kramer (Plainfield, N.J.), S. E. Coen (Long Meadow, Mass.), Dr. and Mrs. Lionel Casson (Rome, Italy), Gene Crane (Philadelphia), Mr. and Mrs. Henry Marcus (Chicago); photograph—Oliver Baker. 1956.

IL RATTO D'ITALIA II: ed. 12; collections—Mr. and Mrs. Alden Dow (Midland, Mich.), Mr. and Mrs. Foster Harmon (Naples, Fla.), Mrs. George Kaplan (Farmingdale, N.Y.), Mr. and Mrs. Robert Rubin (New York), Mr. Jerry Stern (New York); photograph—Oliver Baker. 1957.

SAGITTARIUS (ZODIAC SCREEN MODEL): ed. 3; collections—Armand G. Erpf (Arkville, N.Y.), Senator William Benton (Southport, Conn.); photograph—Soichi Sunami. 1957–1958.

SCORPIO (ZODIAC SCREEN MODEL): ed. 3; collection—Senator William Benton (Southport, Conn.); photograph—Soichi Sunami. 1957–1958.

SEEDCAKE: ed. unique; collection—Lee Nordness Galleries; photograph—R. Baldi. 1967.

SHAKESPEARE'S MIRROR: ed. unique; collection—Lee Nordness Galleries; photograph—Walter Rosenblum. 1968.

SIESTA: ed. unique; collection—Lee Nordness Galleries; photograph—Oscar Savio. 1970.

SIGNORA BETETA: ed. unique; collection—Lee Nordness Galleries; photograph—Oliver Baker. 1956.

SIRENS: ed. unique; collection—Samuel S. Berger (Scarsdale, N.Y.); photograph—Geoffrey Clements. 1966.

SMALL EXORCISM: ed. unique; collection—Lee Nordness Galleries; photograph—Geoffrey Clements. 1964.

SPANISH DANCER: ed. unique; collection—Mr. and Mrs. Raymond Barna (Great Neck, N.Y.); photograph—Geoffrey Clements. 1963.

SPHINX: ed. unique; collection—the late C. V. Starr and companies associated with him; photograph—Oliver Baker. 1959.

STORM I: ed. unique; collection—Lee Nordness Galleries; photograph—Walter Rosenblum. 1961.

STORM II: ed. unique; collection—James Boslow (New York); photograph—Geoffrey Clements. 1962.

TAURUS (from ZODIAC SCREEN): ed. unique; collection—Pan American World Airways, J. F. Kennedy International Airport; photograph—Walter Rosenblum. 1960.

TELEMACHUS: ed. unique; collection—Lee Nordness Galleries; photograph—Geoffrey Clements. 1966.

THE TEMPEST III: ed. 6; collection—the late C. V. Starr and companies associated with him; photograph—Milton Hebald. 1966.

THREE GIRLS: ed. unique; collection—Fairmont Park Art Association, Schilling Purchase Prize (Philadelphia); photograph—Fairmont Park Art Association. 1940.

THREE GRACES STUDY: ed. 8; collections—Mrs. Lewis Cowan Merrill (New York), Mrs. Samuel LeFrak (Woodmere, N.Y.), Edward S. Shulman (Elkins Park, Pa.), Bruce and Jay Colen (New York), Mr. and Mrs. Arthur Murray (New York), Milton Haller (New York), David Unterberg (New York); photograph—Oliver Baker. 1959.

THREE GRACES II: ed. 6; collections—Lee Schooler (Chicago), Saul Shapiro (Montreal), Mrs. Joan Avnet (New York), Mr. and Mrs. Harry Sharfler (New York), photograph—Geoffrey Clements. 1959.

THREE GRACES III: ed. unique; collection—Lee Nordness Galleries; photograph—Soichi Sunami. 1961.

THROWING THE BULL: ed. unique; collection—Mr. and Mrs. John F. Lott; photograph—Geoffrey Clements. 1950.

TIDE IN: ed. 6; collection—Lee Nordness Galleries; photograph—R. Baldi. 1967.

TIGHT ROPE: ed. unique; collection—Lee Nordness Galleries; photograph—Geoffrey Clements. 1947.

TREE OF LIFE: ed. unique; collection—Mr. and Mrs. Lester Bergman (Hiridge, N.Y.); photograph—Lester Bergman. 1948.

TRIPTYCH: ed. 12; collection—Lee Nordness Galleries; photograph—Thomas Feist. 1967.

TRYST: ed. 6; collections—Mr. and Mrs. John Kluge (New York), Mr. and Mrs. Grover Mollineaux (Old Westbury, N.Y.), Mr. and Mrs. Robert Doty (Rome, Italy), Mr. and Mrs. Harold Toppel (San Juan, P.R.), Mr. and Mrs. A. A. Rosen, Mr. and Mrs. Morris Messing (Nutley, N.J.); photograph—Walter Rosenblum. 1964.

TWO IN THE WIND: ed. 14; collections—George

Herrick (New York), Nat Aronsohn (New York), David Foster (Los Angeles), Mr. and Mrs. Saul Rosen; photograph—Geoffrey Clements. 1963.

UNDER THE APPLE TREE: ed. 6; collection—Lee Nordness Galleries; photograph—Geoffrey Clements. 1963.

UNDERWATER FOUNTAIN: ed. unique; collection—Mr. and Mrs. H. H. Boscowitz (New York); photograph—Milton Hebald. 1963.

VAN ETTEN HOSPITAL FAÇADE: ed. unique; collection—Nathan B. Van Etten Hospital (Bronx, N.Y.); photograph—Stoller. 1954.

VIRGO (from ZODIAC SCREEN): ed. unique; collection—Pan American World Airways, J. F. Kennedy International Airport; photograph—Walter Rosenblum. 1960.

WANDERING ROCKS: ed. unique; collection—Lee Nordness Galleries; photograph—Geoffrey Clements. 1966.

WARRIOR: ed. unique; collection—Lee Nordness Galleries; photograph—Oliver Baker. 1957–1958.

WILLIAM HAYES ACKLAND MEMORIAL: ed. unique; collection—University of North Carolina (Chapel Hill); photograph—University of North Carolina Photo Lab. 1961.

THE WIND: ed. unique; collection—Lee Nordness Galleries; photograph—Oliver Baker. 1955.

WINDBLOWN: ed. 6; collection—Mr. and Mrs. Alan W. Kahn (Nobelsville, Ind.), Mrs. Edwin Stern New York), the late C. V. Starr and companies associated with him, Morgan Knott (Dallas); photograph—Soichi Sunami. 1961.

WOMAN INTO CHAIR I: ed. unique; collection—Columbia Museum of Art (Columbia, S.C.); photograph—Geoffrey Clements. 1963.

WOMAN INTO CHAIR II: ed. unique; collection—Leo Bakalar (Boston); photograph—Geoffrey Clements. 1963.

WOMAN WITH BIRDS: ed. unique; collection—Whitney Museum of American Art; photograph—Oliver Baker. 1947.

WOMAN WITH DRAPERY I: ed. 6; collections—Mr. and Mrs. Ralph Pomerance, Mr. and Mrs. Saul Rosen; photograph—Geoffrey Clements. 1957.

WOMAN WITH DRAPERY II: ed. unique; collection—Adolph Fine (New York), Whitney Museum of American Art, given in memory of Samuel L. Stedman by his wife; photograph—Geoffrey Clements. 1960.

ZODIAC SCREEN: ed. unique; collection—Pan American World Airways, J. F. Kennedy International Airport; photograph—Pan American Photo Lab. 1961.